EROTIC TICKLING

EROTIC TICKLING

by Michael Moran

illustrations by Chris M.

greenery press

Published in the United States by Greenery Press, 3403 Piedmont Ave. #301, Oakland, CA 94611, www.greenerypress.com. ISBN 1-890159-46-8.

TABLE OF CONTENTS

Introduction

Erotic Tickling is a kink for the new millennium. It is gentle and playful, suggestive of innocence and the frolics of children, yet capable of inducing powerful orgasms. Although more people are becoming aware of tickling as an erotic practice, some remain skeptical at the thought that tickling can be anything other than mere foreplay. The purpose of this book is to eliminate that skepticism by presenting ideas and scenarios that show how tickling can be a highly sexual activity.

Before going on, let us define Erotic Tickling as the feather-light, insistent stroking, teasing, or caressing of sensitive body parts to create sexual excitement and gratification, often used during a bondage session.

The concept of Erotic Tickling will invariably produce one of three general responses in the reader: aversion, interest, or desire. It is useful to address each of these general responses in turn.

Aversion: Many people are uncomfortable with the idea of being tickled, or of tickling others. Tickling has never felt good to them, and they consider it a

kind of sadism. Some are able to steel themselves against the onslaught of tickling by willing an absence of the usual sensations that occur when a sensitive area is probed by a feather or fingertips. But most tickle-averse people may have responses to tickling that include panic or incontinence. This book will help such readers see tickling in a new light, for I have written this book primarily for those who regard gentle, consensual tickling as an enchantment, a fillip, an erotic game designed to elevate lovers to the highest level of sensuality.

Interest: The universal response of laughter to tickling (indeed, most people will laugh while tickling others, or while watching others being tickled) is a sign of the pleasure inherent in the act of lightly stroking or kneading sensitive body parts. Havelock Ellis pointed out that laughter as an explosive response to tickling is a kind of detumescence. Any way you look at it, there is a subtle — and sometimes overt — sexual connection to the practice of tickling. So for those who are not repelled by tickling, some degree of interest is usually present, as an aspect of general sexual curiosity. Thus, the spectrum of interest may be said to range from mild curiosity to an energetic focus on the erotic elements of tickling.

Desire: Those inhabiting this charmed area are probably reading this introduction not in the aisle of a bookstore — where others may be deliberating whether to actually purchase the book — but at home, in their bedrooms, ideally in the company of a loving partner. They already know that Erotic Tickling is right up their alley, and they are avid to learn all they can on the subject, and to be highly stimulated in the process. To those readers I dedicate this book. May

they achieve the ultimate fulfillment of their sexual desire, while never losing sight of the truth that the act of giving and receiving erotic pleasure is among the highest expressions of love, and is thus worthy of ongoing practice, devotion, and inquiry.

Author's Note

In the interest of brevity, and to create a sense that the activities described herein are not to be initiated exclusively by the man or the woman, I freely and often interchange the use of male and female pronouns, occasionally in the same paragraph.

Because of my personal orientation, I use the heterosexual paradigm throughout this book. Erotic Tickling is thus presented as a prelude to sexual interaction between a man and a woman. The lack of reference to same-sex activity should not be viewed as censure or indifference. We are all sexual beings, and must express our sexuality — whatever form it takes, so long as it is loving and consensual — or become crabbed and neurotic. I am confident that practically everything here that works for heterosexualists (to use a word coined by Gore Vidal) will work for gays, lesbians, bisexuals, and the transgendered as well.

Getting Started

To get the most out of Erotic Tickling (hereafter abbreviated as ET — with apologies to Stephen Spielberg), you need a loving and interested partner. If you are alone in life and must rely on masturbation for sexual release, I have prepared words of solace and hope for you at the close of the book. But to begin, let us assume that you are in a mutually satisfying sexual relationship, and that your goal is to enhance it while exploring a new avenue of titillation.

Start by sitting or lying opposite each other on the bed, or anywhere you like, completely nude or in whatever state of partial undress you find arousing at the moment, and look into your partner's eyes. As you may already have discovered, the deepest erotic connections begin with eye contact. The cliché of the eyes being windows to the soul is a cliché because it is so true and because so many have expressed this truth. When you look into

the eyes of the person you love, and to whom you are physically attracted, you connect at the deepest level of your being, and all the erotic activity that follows is more natural and more electric than if you proceed directly to the so-called "erogenous zones" and begin the standard maulings and mouthings that men, at least, usually assume are sufficient to bring a woman to her peak of pleasure. I have placed "erogenous zones" in quotation marks because without careful and sensitive handling, these areas can be remarkably unresponsive. And I have, and will continue, to speak directly to men in these pages because as a man I am fully aware of the help we often require to shape ourselves into more caring and sensuous lovers.

Although this is not the place for a discussion of the relative merits of men and women, I must say that experience has shown me that many women possess a natural grace and tenderness that enables them to prolong and protract sexual union well beyond the rapid, instinctual drive toward procreation that makes dullards of so many men. Exceptions abound, of course, and gaggles of women will protest that a good quickie with a randy and ready stud is just fine, thank you. And men will claim they have as much talent for sensuality as women. But my point is that in general a woman is better pleased if a man takes time and shows care in lovemaking. And that is why we begin our exploration of ET with eye contact, and move next to expression through words.

Words, which play on the heart like a bow upon a violin, also pluck very nicely at the taut strings of the libido. Your use of words as you practice ET will greatly increase the pleasure for both of you. Start with a confession. Tell your lover — shyly, for that's part of the fun of it — where you are most ticklish. It may go something like this: "My most ticklish spot is…(and here you pause for effect, and perhaps even blush a little) my underarm." (Or ribs, or neck, or feet — wherever.) "Really?" says your partner. "Well then, why don't we try a little experiment?"

At this point he very gently begins to take control. If you are lying together in bed, fully nude, he takes your wrist and stretches it out above your head, while draping his leg across your pelvic area. In this way you are rendered partially helpless by his hand on your wrist and his weight upon your body. This kind of semi-helplessness, a mild form of bondage, is necessary if you are to experience the full power of ET. Assuming you are with a person you love and trust, the elements of fear and anxiety produced by this helplessness will be entirely symbolic, only adding fuel to the fantasy of control by a dominant partner. If even this gives you trouble, simply stretch out your limbs yourself, enabling you to stop the process immediately and without resistance from your lover. The only rules in loveplay are the ones you set up in advance to make yourself completely comfortable.

Now he continues, telling you what is about to occur. "Your armpit is very sexy," he says. "I see that it's recently shaved, and sweetly perfumed." (Or soft with down, or rich with the scent of your natural musk, if either of those are your mutual preferences.)

"And now I shall begin my experiment. We will see exactly how ticklish you are, and how much of my tickling you can withstand." As he speaks he will gently tighten his hold upon you, as you become more tense and feel the increased thudding of your heart. Skillfully, he will bring his fingers slowly forward, describing their approach through what seems to you an infinity of space. And by the time the tips of his fingers actually connect with the flesh of your underarm, your nerve endings will be primed for the acute pleasure of ET.

By describing everything he is doing, or is about to do, the adept lover adds a delightful dimension to the experience. You are now in the thrall not only of sensation, but of sound. The word "tickling" will become heavy with erotic power. However, some people prefer silence during sex. Obviously, certain preferences and dislikes must be addressed ahead of time, or feelings

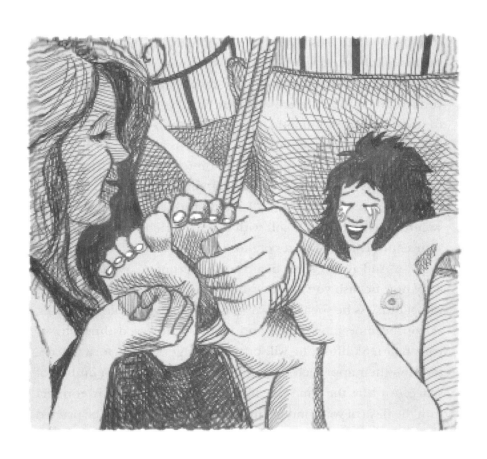

may be hurt and sexual energy dissipated in defensive verbal exchanges. The sacrifice of spontaneity is often required for maximizing pleasure, which is the ultimate goal of ET, or any other form of sexual expression. Communication is essential, and will pay the greatest of dividends.

At this point in your erotic journey, you will become quite alert to the degree of ticklishness you possess. It is important to begin the tickling in as gentle and slow a manner as possible. Too hard and abrupt an approach can ruin the experience before it has had time to be appreciated. Again, if your desire is to be roughly tickled in the manner so often seen in schoolyards and at family gatherings, where bullies and depraved uncles have their way with helpless children, so be it. You must not feel guilty or ashamed if your sexual landscape contains elements of dominance, submission, or sadomasochism. If you have a consenting partner and no one is being abused, your desires are more than okay — they're fantastic! But as a rule, proceed slowly and tenderly with ET. Your nerve endings are likely to be very sensitive to tickling, even if the idea of it turns you on. A gentle approach will allow you to get used to the sensation, which can be perilously close to pain or discomfort.

Now that the tickling has begun, the aspect of time, or duration, can be brought into play. During the experience of being tickled, a sense that it may never stop — that the delicious torment will continue forever — can be most exciting. Being told that the tickling will never cease may bring you to the brim of ecstasy, for it marries the idea of eternity to the feeling of acute, almost unbearable pleasure. This is all very philosophical, but the bottom line is that it will really turn you on. And the more turned on you are, the more turned on your partner will be.

Of course, the reality is that if you feel pleasure for too long, it begins to lose its edge. Here common sense comes into

play. Prolong the tickling of this first area, but recognize, through your partner's body language and responses, when it is time to move on. And then proceed to the next ticklish body part.

Experimentation by the tickler is now recommended. The ticklee should be in an almost breathless state of arousal, and may not wish to express herself in anything more than groans of pleasure. Now it is up to you, the tickler, to find out all the other secret and sensitive places where tickling fingers (and a tickling tongue — but we'll get to that later) can be most effective.

If you have started at one armpit, go to the other one. Straddle your partner, holding both her wrists above her head with one hand, and tickle first one, then the other armpit. If she can stand it, have her hold her arms up by herself, and tickle both underarms at once. (At this point bondage — a subject discussed in the next chapter — is a useful employment; but for beginners it may be a bit much.) From here on it is your duty and pleasure to free-lance. Concentrate on traditional tickle-parts (ribs, feet, etc.) and explore any other area that is soft and sensitive. The insides of the arms and elbows can be extremely ticklish, and the insistent stroking of these parts has been known to trigger orgasms in some women. Thighs, knees, toes, the neck, the lips — the human body is a veritable buffet of sensuality in the hands of a devoted lover!

Avoiding the primary erogenous zones — breasts, and the genital-anal area — is an excellent strategy at this point. In the first place, these areas are seldom actually ticklish. A man's penis or a woman's clitoris will respond to the lightest of touches in an entirely different way than, say, the bottoms of the feet. When the genitals are "tickled," the orgasm, which one hopes to delay, is usually close at hand. Secondly, postponement of genital stimulation keeps the focus on other body parts; if one is tingling with ticklishness from head to toe, the first touch or kiss upon the

genitals will be truly mind-blowing. And this, after all, is the real purpose of ET: to function as an extraordinarily effective means of foreplay, priming the entire body to respond to sexual interaction with a power that surges upward from the core of one's sensuality.

Toward the end of this foreplay, or earlier, if one is so inclined, the tongue should be used creatively and generously. All of the nerve endings that danced to the touch of your fingers will practically explode as the soft, pliant tongue traces the outlines of ecstasy upon ribs, knees and toes. And if the genitals are to experience any real tickling at all, it is most likely they will do so at the teasing insistence of the tongue. The clitoris in particular is an excellent repository of tongue-tickle energy. The Germans, avid devotees of sexual pleasure, call the clitoris "Kitzler," which in their language means "tickler." This should be a reminder that the clitoris usually responds best to a light touch rather than ham-handed rubbing.

For the fastidious who cringe at the thought of licking an armpit or instep, thorough washing and the application of flavored gels may be the answer. But if your partner enjoys tickling you with fingers or feathers, be grateful for that and don't push for tongue-tickling if it is not offered.

When your partner is thoroughly tickled and incredibly aroused, it is your turn to lie back and become the ticklee. Enjoy your lover's tenderness and creativity, and when you can take it no longer it is time to initiate sexual interaction, and you must now proceed more carefully than ever, for if your adventure in ET has run its course, you will both be so incredibly hot that there is the strong likelihood of a premature orgasm.

But this is a happy problem, right?

Now you are faced with the delightful responsibility of prolonging your climax until your lover has reached the pinnacle

from which she will easily plunge into the oceanic orgasm that all this tickling has engendered. Or perhaps it will be she who holds back until the last second, riding the waves of *your* orgasm into her own. If you are really daring, you will continue with some light tickling even as you make love. When you thrust deeply and gently within her, hold yourself up, keep your penis rigid against her pulsating clitoris, and tickle her sides and armpits. For the woman, balance yourself upon his erect phallus — rising slowly up and down for as long as you can stand it — and use your free hand or hands to tickle his ribs and midsection very lightly.

If you are giving oral sex, masturbating your partner, or using a vibrator or other toy, use this same method of combining tickling with genital pleasuring for powerful results. However, you both may find that this is too much stimulation. In some people, and especially at the moment of release, it can even be distracting. But for others it will create a synergy of sensation resulting in the most powerful orgasm of their lives. Personal preference will determine the outcome for you. And if an orgasm is compromised by the distraction of faulty experimentation, how bad is that, really? You are both fine-tuning, and you have uncountable orgasms ahead of you. Understanding and a sense of humor are as important for good sex as any other factors you can name. ET, with its built-in components of laughter and the sense of fun, will go a long way toward gifting your life with wonderful sexual union, as often as you like, for who among us grows tired of laughter and fun?

Now that you have completed your first course of ET, and are lying next to your lover in a state of mute exhaustion and tingling ecstasy, it is worth noting that in the post-orgasmic state a person who normally enjoys the sensation of tickling may find himself suddenly, inexplicably ticklish in the manner of those previously referred to as being averse to tickling. Being tickled

after orgasm may produce shrieks of laughter and the assumption of the fetal position. Since this is not always desirable, proceed with caution. In contrast, some who are normally repelled by tickling now find the sensation pleasurable! We are indeed strange and unique creatures, which is why we enjoy playing with each other so much.

2 ACCESSORIES

It is the opinion of the author — and the opinion also of many of his correspondents — that the most sensuous tickling is accomplished with a light touch of the fingertips. But variety in any pleasurable activity is always welcome, and the use of accessories will add zest to the sex-play of mutual ticklers.

Feathers: Other than fingertips, the feather is the most popular and time-honored accessory for tickling. The type of feather used depends first upon the ticklishness of the body part. The relatively tough soles of the feet may require the rapid tickling of a stiff and pointy goose feather for full effect; the instep, generally softer, may respond to the lighter touch of a fluffier feather. Here is the general rule: the tougher the skin, the stiffer the bristle. Ribs and the insides of the thighs or arms, for example, should not be tickled with stiff feathers, as the sensation will be closer to an itch than a tickle. (This

is not an unnecessary exercise in semantics. ET aficionados will be interested in distinguishing between the two sensations. For our purposes, an itch may be considered more intense, and generally disagreeable, discomfort bordering on pain; a tickle is more electric, decidedly sexual, and never painful.)

Feathers can be gotten from all sorts of places. They can be purchased at craft shops, or plucked from hats, or extracted from down pillows. If you have a canary, save the brightly colored feathers discarded during molting. Although quite small, these feathers are sturdily constructed yet have a soft tip, and are almost perfect for tickling very sensitive body parts; a canary feather playing in between a ticklee's toes will have a riotous effect. Woodland strolls will take on new meaning for ET couples, as the search for feathers becomes exciting. (By the way, it's a good idea to "decontaminate" found feathers by lightly combing them out and leaving them in the sun for a few days before using them on your partner, especially if the feathers will be tickling the lips, face, clitoris, or any other part of the body where bacteria or mites could gain a foothold.) Large, stiff feathers may have limited use, but a collection held in a vase next to the bed will be a pleasant reminder of tickling in general. Do not underestimate the effect of the feather as totem.

Bracelets and jewelry: On a woman's wrists and ankles, bracelets are a wonderful enhancement during tickling. The jangling and flashing of a bracelet festooned with charms will delight the ticklee. Construct a bracelet with feathers hanging down, and the flesh will be further tickled as the wrists and ankles pass over it en route to other tickle venues. Pendants and earrings — anything that dangles —

can be used to tickle body parts resistant to the lighter touch of fingers and feathers. Toe rings draw attention to the feet, which most lovers of tickling find to be highly charged with sexual energy, as they are so sensitive to tickling. All of the associations of jewelry — adornment, femininity, even barbarism — will heighten the experience of ET, just as they will intensify any other romantic and sexual encounter.

Bondage equipment: The use of restraints is thoroughly covered in the next chapter, but some mention of bondage accessories is useful here. The basic ET rule for restraints is this: comfort above all. Restraints should neither chafe nor cut off circulation. Their goal is to keep the limbs immobile, and the body vulnerable to tickling. Anything used for restraint during ET will possess a power that extends beyond the moments of sexual activity. For those couples who do not have inquisitive children nosing about, a closet full of hanging restraints will serve as a daily reminder of the special nights of ET that await them. Pumps with ornate ankle straps worn at dinner will remind the male tickler that his lover's ankles will soon be secured by similar straps to the bedposts. And the feather-bracelet tickling the air as a woman casually turns the pages of her magazine will send a shock of desire through the loins of the tickle-slave in observance.

Mirrors: As with sex-play in general, mirrors add an erotic tang to the experience of ET. A mirror on the ceiling or next to the bed will double the pleasure of both the tickler and ticklee. Placed at the foot of the bed, a wide mirror will reflect the normally unseen bottoms of the feet as they strain against tickling.

Brushes: After feathers, these are the most popular tickling aids. Best are the thin brushes used for watercolor painting. A kit of these will contain brushes of varying thickness and stiffness. Much time and pleasure can be spent in determining which brushes are best suited for what body parts.

Fabric: Furs and velvets may produce tickling sensations in some people, depending on what body parts they are rubbed. A silk scarf drawn slowly across a lover's chest or stomach is a nice erotic maneuver that may or may not cause tickling; this is a good way to introduce a hesitant partner to the joys of ET. As with jewelry, anything that hangs and dangles can be useful to the tickler. Hair, while not a fabric, should also be tried if the woman (or the man) has long tresses.

Clothing: Since ET involves the element of control, outfits traditionally worn by dominants will prove sexy. The idea of being tied to the bed and tickle-tortured is enhanced if the tickler is decked out like a dominatrix or executioner. In this way the psychological component of S & M is given ample play.

Any item of clothing that exposes a part of the body to be tickled is also desirable. Belly shirts, tank-tops, and sandals allow furtive tickling strikes at sides, armpits, and toes during a date. (Be sure your "date" is already simpatico with ET, or you'll get some pretty weird looks and the door slammed in your face.)

As tickling is very much an activity practiced and enjoyed by children, the subtle tie-in of tickling with infantilism cannot be overlooked. (Infantilism is discussed in the chapter on Problems and Solutions.) If you and

your partner are turned on by the childlike, playful aspects of tickling, by all means explore this very safe and amusing avenue. Bobby-sox, a checked gingham shirt and a ponytail will transform a mature woman into a tickle-crazy babysitter. Pot-bellied, fifty-something adults can change into their jammies and tickle each other silly and feel like a couple of kids again — although the passionate sex that follows may puncture the fantasy. (But by then, who cares?)

Tight shoes, or socks made of scratchy wool can also be useful to the ET couple who are into feet. Feet lightly sweating and pinched half the day in cotton socks and tennis shoes will be excruciatingly tender and ticklish when suddenly made bare. And those same poor feet when encased in scratchy wool socks and loafers will already have their nerve endings standing at attention when the shoes and socks are removed by an ardent tickler.

Fingernails: Whether you are driven wild when tickled by soft fingertips or sharp fingernails depends on your tickle-orientation. But even the most intractable devotee of "soft tickling" can be royally turned on by the clever use of long, painted fingernails. For the man, the sight of colored fingernails is a well-known turn-on. The woman is thus aroused by the knowledge of her own power and femininity. And while fingernails may be inadvisable for the tickling of softer parts, scratching the nails on a slightly calloused area like the heel might be just what the sex-doctor ordered. Even long nails can feel feathery if the tickler is a sensual artist. Toenails should always be trimmed (for aesthetic reasons, and also to avoid ripping your partner's flesh during tickle-convulsions), and a wise lady

will always keep them polished and colored. ET men usually like feet, and will be drawn to painted toenails.

A custom-made tickle extender: Here is a device invented by one of my ET correspondents. Its usefulness will be apparent to those who enjoy tickling a lover's feet while giving head or masturbation. It is simply a backscratcher upon which two or three feathers have been glued at the curved tip. This provides the tickler with a reach-around device for tickling soles and insteps while teasing a clit or penis with the other hand, or with the tongue. This same correspondent (and a very clever correspondent she is, and no, I'm not going to give you her name and address) found the curvature of the backscratcher to be insufficient to the task at hand. The feathers tended to reach only the sides of the insteps and soles, leaving large expanses of bare feet untickled. Her solution? A wire hanger, untwisted and fashioned into a question mark-shaped foot-tickler. The curved end of the device is more than adequate to reach those ticklish soles and insteps, and her very fortunate tickle-victim now regularly experiences merciless foot-tickling at the moment of orgasm.

Remember: Your use of accessories is limited only by your imagination.

3 B O N D A G E

I
f you have the slightest doubt that fantasies of bondage permeate our culture, page through a fashionable magazine, or channel surf through an evening of R-rated films on HBO and Cinemax. The dominatrix, the slave-master, the bound victim — these are the images you will encounter. The idea of tying up your lover and giving him — and yourself — a good time has become almost commonplace among the sexually sophisticated, and even less adventurous couples can be seen at novelty shops giggling over the "bondage kits" that contain cheap plastic handcuffs and fluffy red feathers. So prevalent has this fantasy become that it is considered a quite healthy, if somewhat kinky, diversion, and for most of us the negative elements of this practice have been pushed aside. Still, it is wise to keep in mind that bondage can be heavily freighted with negativity; it is, after all, a standard practice of the torturer, the rapist, the serial killer. That kind and loving people can be turned on by bondage is a topic far beyond the scope of this book. For our purposes it is only necessary to remember two things: bondage can be great fun and there's

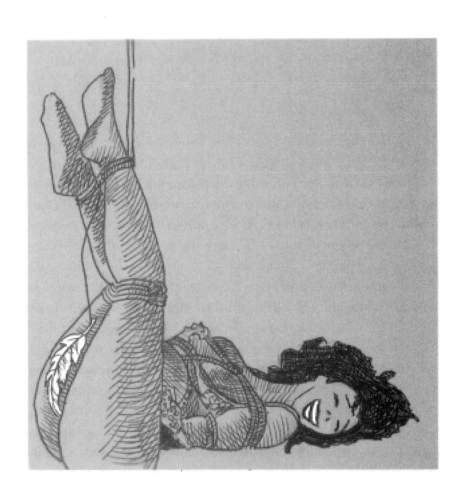

nothing wrong with it; but one must be cautious, as bondage can be frightening or disagreeable for some people.

For the Erotic Tickler, bondage is as essential as a spice rack to a master chef. In the previous chapter a scenario was described in which a lover's wrists are held above the head so that the underarms are vulnerable to tickling. This is fine, but if the wrists — and the ankles as well — are secured to the bedposts, the session takes a quantum leap forward. Now the tickler is free to employ both hands, and to tickle different parts of the body at the same time. And the ticklee is now powerless to stop the tickling. This is both physiological and psychological dynamite. Sexologists have pointed out that the muscular tension created by straining at bonds increases sexual arousal. Add to this the "torture" of being tickled, and the result is sexual vulcanism: the taut, tickled body is a Vesuvius on the verge of eruption. Try this once, and the chances are good you will never again practice ET without the added pleasure of bondage.

Now for some guidelines.

First, you will need a bed. Four-posters are ideal, but even the simple legs of a hospital bed will suffice. Brass or metal beds with ornate headboards are a delight, as they allow the dominator artistic license in threading the restraints through and around all the openings. A love-victim whose wrists, thumbs and fingers are elaborately bound to complicated latticework knows he is in for a special evening. (Be advised, however, that such latticework could be damaged by struggling.) The time and care employed in the act of binding can be a welcome portent of the concentrated attention that will soon be devoted to his naked and vulnerable tickle-parts. On the other hand, an elaborate set-up may not be to your mutual taste. The quick binding of your wrists and ankles with scarves is perhaps all you need in your happy haste to get right to the tickling. As always, taste and preference

rule. You may prefer to be tied to a chair, or to be staked out on the rug, or pilloried in an old-fashioned stock (if you can find or make one). I know of one couple who had a great time with a doctor's metal examining table. This seemed rather sterile and cold to me, but for them the fantasy of the dominant nurse and the helpless, ticklish patient was powerfully erotic. Your imagination and pleasure in games will guide you best here. But a bed remains the choice of most Erotic Ticklers, for its pleasing associations of comfort, love, and sexplay.

Restraints are the next thing you will need. Old stockings are a favorite, but they can become painfully tighter as the ticklee struggles, and once the knots have tightened, good luck untying them. You will, in fact, require some tools for quick release. Knives are not recommended, especially in low-light conditions. They can slip while cutting restraints, particularly if the bound person is clamoring for freedom and the stress level of both partners is high. Scissors are better; look for "EMT scissors," designed for use by medical personnel who need to cut easily through bandages, straps, and heavy cloth, and which have relatively blunt tips. These can be purchased from medical supply houses, but may also be found in some drug stores. It's also a good idea to have needle-nose pliers available, for poking into tight knots and then tugging them open.

And don't forget to choose a "safe" or magic word, which when cried out will alert the dominator that you definitely want to be released. Even though the tickle-torture may be transporting you to paradise, part of your fantasy could be begging for mercy, and if this is the case your highly focused tickler might ignore a sudden change in the pitch or intensity of your entreaties, unless the blurting of "tapioca" or "Dubya" –something completely unrelated to the fun and games at hand — clues him that you have suddenly developed a cramp in your big toe. Silk scarves, bandanas, stretchy socks, belts, literally any kind of fabric

can be fashioned into a restraining device. The key is to ensure comfort and pleasure at all times. Ropes or rough cords might chafe if the top is unskilled. Anything tied too tightly will block circulation to the hands and feet, causing numbness or pain. Real handcuffs are too harsh, and god help you if the key is misplaced. Unless you have a hacksaw available, prepare yourself to do some explaining to a grinning locksmith. A special trick is to wrap soft padding around the wrists and ankles before applying the restraints. Saran Wrap, of all things, is an extremely effective restraining device. Stretched into long, thin strips and wrapped around the limbs and bedposts, it proves quite impossible to wriggle out of. (Don't forget to keep those scissors handy.) But it can become very tight, and definitely requires padding underneath.

A creative lover will fashion specialized, unique, custom-made bondage restraints. A man who thinks accompanying his wife to a fabric store is drudgery may find the experience altogether different when the object of the trip is to assess and gather materials for the construction of restraints. He will suddenly take a great interest in satins, crushed velvets, snaps, hooks and Velcro fasteners. Custom-made restraints might be stored in a special cloth bag or box, perhaps of Oriental design, as this will add to the atmosphere of exotica.

Regarding position, it is usually most advantageous to have the ticklee on his back, spread-eagled. In this way all the sensitive parts, including the genitals, are open to the tickler. Hands tied behind the back will restrict access to the armpits, and ankles tied together will close off the thighs. And while on his back the ticklee will be able to see the laughing face, gleaming eyes and approaching fingers of the tickler. (Note: blindfolding can be an effective variation here, as the ticklee will be continually surprised by the tickler's attacks.) If your lover's backsides are more erotically ticklish than her frontsides, then tie her to the bed face down.

(But beware of a soft mattress or padding that could make it difficult for her to breathe.) Whatever works for both of you is best.

Let us now examine an especially creative bondage/ET scenario that has been described to me by a couple who have practiced the art of ET for many years. They came up with the following completely on their own, without suggestions from any sex manual or from other people. If you find it sexy, you will certainly want to try it yourselves. And through personal exploration you will no doubt create other scenarios that only you could have devised.

In soft candlelight, and in a comfortably warm room, a naked man is spread-eagled upon the bed, his wrists and ankles securely fastened to the bedposts. The restraints are black velvet wrist and ankle cuffs generously lined with plush fabric and cheerfully decorated with faux gemstones. Sewn onto the cuffs are satin cords that can be wrapped around the posts and tied in escapable knots.

The cuffs themselves are fastened around the wrists and ankles by means of Velcro attachments. Here we have the work of a creative seamstress. The man is fully comfortable, and utterly helpless.

On a nightstand next to the bed sits a tray of accessories: lotion, feathers, soft brushes, and… what's this? A stack of paper Dixie cups, the smallest size available. Their purpose will be apparent in good time.

Now the woman, dressed only in a pink flannel pajama top (which for some reason the man finds incredibly sexy), places the small tray upon the bed next to her love-victim. She sits between his outstretched thighs, draping her soft, recently shaved legs next to his ribs. Her painted toes rest inches from his armpits; he can feel the warmth of their proximity. Now she takes a squirt of peach-scented lotion and rubs it into her hands and fingers. She then applies the lotion to one of her feet, then to the

other. As she raises each leg to bring her feet within reach, the man has an excellent view of her thighs and vulva. (His head has been thoughtfully elevated upon a couple of pillows.)

"Well," she begins, "are you ready for a night of torment?"

The man is speechless. He tests the bonds a little, but cannot escape.

"I am going to subject you to increasingly heightened levels of tickle-torture. As you reach the highest levels, your agony will be quite unbearable, I assure you. Your cock will be rock-hard, and your balls will be bursting with the pressure of imprisoned sperm, all the little fishies straining and clamoring to explode through the tip of your throbbing, pulsating cock."

Here the man groans. Yes, this woman is not only a master seamstress, but a master of sex talk as well. She continues.

"If you are very, very good, I might favor you with the release of an orgasm, the greatest, most powerful orgasm you have ever felt. But until I decide that you are so deserving, you will have no relief, only the sweet agony of tickle-torture, and the hope that your helpless cock and balls will at long last feel the touch of my lips and tongue."

And so her ET monologue proceeds. She tells him in loving detail what she is doing to him, and what she is about to do to him. First, she tests his tickle-parts with her delicate fingertips. Her touch is light and slow, beginning at his accessible thighs and knees. She leans back and playfully tickles the soles of his feet, his toes, his insteps, lightly scratching his somewhat calloused heels and the sides of his feet with her painted nails. Then she leans forward again, trailing her fingers along his legs, knees, thighs, belly and at last to the ribs, where she decides to linger awhile, even as her delicate toes have begun to tickle the hairs in his armpits. She tells him that he is doing very well so far, but that he must remain perfectly still throughout the ordeal so as not to

disturb her concentration. Any sudden movements will result in her displeasure, and punishment will be the prolongation of the torment without any touching or kissing of his cock and balls. Happily she hums along with the music playing in the background as she absorbs herself in the tickling. For the man, the sensations are wildly intense, but he remains still, enduring it as best he can.

"Very good," says the woman, stopping for a moment. "But let's see how much of the feathers and brushes you can take. It's time for the second level."

Now she employs a feather in one hand, a brush in the other, ranging from armpit to toe, in long strokes and circular teasings both. Finally the man can bear it no longer. A small cry and a stream of laughter escape his lips. He pulls in vain at his bonds, and his movement drives the woman slightly backwards, her legs and feet rising in the air.

She laughs. "So," she says, "level two wasn't enough for you, was it? Now you must endure the third, most agonizing level. From level three there can be no escape without full obedience to my wishes. Prepare yourself for the torture of your life."

With that she lifts the stack of cups from the tray. She places one each upon the man's forehead, chest, and stomach. There is a cup as well for each knee, and for the inside of each elbow. (On another night she will devise the technique of propping a coin or button upon each big toe, thus keeping the feet from moving or the toes from curling.) She explains that the cups must not fall off under any circumstance. If their balance is precarious, and if her own movements should dislodge them — too bad! She further explains that she has preset the CD player to play a few of her favorite melodies of varying length. During each song she will mercilessly tickle the man, perhaps even with more force than he is used to. When the song ends, she will stop, and he will have a moment to catch his breath. But in a few seconds another song will begin, and with it another ordeal of ceaseless tickling. He

must get through the entire program without dislodging a single cup, or the entire process will start all over. How many songs have been preset? She doesn't remember, but what does it matter? All he needs to know is that he must remain completely still while being devilishly tickled. This increased element of control intensifies the sensation for the ticklee, as now the limbs are not only in bondage to restraints, but to the victim's will power as well. He cannot risk barely twitching a muscle, even though his nerve endings are crackling with tickle-energy. Few victims can endure such teasing, and a cup or two will invariably topple. (A variation is to fill the cups a little way up with ice water, thus upping the ante — nobody really wants to feel a trickle of cold water down his side during sex-play. But for most people, this is too sadistic; empty cups work just as well.) When the ticklee is "bad," and a cup topples to the mattress, the whole process begins again. The cups and the music are reset, and the tickler goes back to the spot that caused her victim to buck and writhe. A clever tickler will linger at that spot for a long time, while explaining that she is now aware of the extreme ticklishness of, say, her lover's neck or armpits, and wishes to inflict maximum punishment while also teaching him the importance of remaining motionless during the most agonizing tickle-torment. She will also remind him that she has all night to play and tickle thusly, and that so long as he continues to misbehave, he will be ruthlessly tickled until sunrise, and possibly beyond.

Of course, this is the stuff of fantasy. Few lovers involved in ET really want to spend an entire night tickling each other, but you get the idea. Hearing that there will be no escape from the tickling — the *idea* of it — is a powerful enhancement of this sensual experience.

Common sense will limit the amount of time spent in tickling without any handling of the genitals. At some point the ticklee will have had enough, and it will be advisable to begin a process

of slow masturbation punctuated by tickling reprises. A few strokes of the hand upon the penis, then a letting go and more tickling. A few more strokes — administered languorously — and more tickling, and so on. In this way the ticklee will be driven to the edge of orgasm. (And don't forget to tickle with one hand and masturbate your lover with the other at the same time, for a truly mind-blowing combination!) At this point it will be up to both partners to decide whether an orgasm should be granted — by continued masturbation, fellatio, or intercourse — or whether the victim should be untied and roles reversed. But probably by now the orgasm should be given; the ticklee will be in a state of frenzy, and it might be too frustrating to prolong it any further.

This kind of sex-play can be so explosive and fulfilling that it is best reserved for special occasions. The couple who devised the above scenario (and who generally tickle each other a little as foreplay, sometimes with light bondage), inform me that too much of even this good thing is hard to maintain. After they tried it the first time, they became obsessed, and intercourse without it seemed too vanilla. But after repeated sessions they grew jaded, and they found themselves focusing so much on the particularity of increased sensation that they lost sight of the tenderness and intimacy that had made their lovemaking so wonderful for so long. Fortunately they figured this out. These days they indulge in the full-bondage/ET passion-play only when they feel they have missed it, or on anniversaries, or as a reward.

As with anything suggested here, personal taste and common sense must hold sway. If bondage seems too extreme, or if talking about "tickle-torture" while you are doing it strikes you as too scripted, employ whatever variations you see fit.

But bottom line, there is no greater enhancement of ET than bondage.

4 BODY PARTS

To give maximum pleasure during ET, you must have a tickle-map of your partner's body. A map in your head is fine, but actually drawing one up is an excellent idea. The most ticklish spots can be colored bright red (or "tickled" pink); the least ticklish, dull gray. In between will fall the yellows, greens, blues and oranges of all the other parts. A woman I know coined the term "tickle-parts," one night when she saw a girlfriend of hers enter the room on crutches. (The friend had suffered a twisted ankle.) Leaning on the crutches forced the injured girl's armpits and sides to be prominently exposed. Instinctively, the woman advanced upon her friend and briskly tickled her armpits. Fortunately the friend was not hysterically ticklish, and only reacted by laughing and pulling away slightly. The woman was immediately embarrassed, and explained her impulsive behavior as an unavoidable reaction to seeing "tickle-parts" exposed. (My interest in this woman as a potential sex-partner was immediately aroused, though nothing ever came of it.)

Anyway, let us now consider the various tickle-parts of the human body, beginning with the most obvious.

Feet: Few sights will arouse the desire of a tickler more than a pair of naked feet propped up on a hassock, or resting on a sandy beach, or protruding from under a blanket. The ticklishness of feet is so well-known in popular culture that the word "tickle" would probably come up as often as "shoe" or "sock" in a word association test with "foot." This is no accident. Other than the palms of the hands, there is no place in the body that possesses more nerve endings. The plantar reflex test — in which forceful stroking of the bottom of the foot causes the toes to curl — is known to every medical student. Cartoons, comic books, movies and TV shows are rife with images of tickled feet, often in connection with light bondage. So it is small wonder that the feet are the first area of interest for many devotees of ET.

The general sexiness of the foot is a subject of debate. On one hand — sorry, one *foot* — we have the fetishist, for whom the act of sexual intercourse may be secondary, or even superfluous, to the kissing, palpation and adoration of his partner's bare feet. (I use the masculine pronoun here because probably 99.9 percent of all actual fetishists are men.) The more accurate term for this kink is actually "partialism" — the true fetishist is drawn to an inanimate object such as latex or shoes, the partialist to a body part such as buttocks, hair or feet. My guess, based solely upon personal observation, is that about half of all men and women consider feet at least marginally erotic, but I am unaware of any statistics to support this view. The point here is simply that feet often play some role in an ET scenario.

This business of ascribing definite terms to people inclined towards certain sexual practices may be useful to psychotherapists and other compilers of case histories, but any attempt to rigidly categorize human sexual behavior is problematic. Technically, a practitioner of ET or any other "kink" might be considered a paraphiliac, defined by a popular web-dictionary *(www.howtohavegoodsex.com/Dictionary.htm)* as one who has "a condition… of being compulsively responsive to and obligatively dependent upon an unusual and personally or socially unacceptable stimulus…" If in the throes of sexual ecstasy you choose to ponder the social acceptability of tickling, and wonder precisely what label should be applied to your sweaty forehead, so be it.

In bondage, ankles can be tied together, thus placing the feet right next to each other for dual access. Both feet tickled at the same time is electrifying for most ticklees. Pumicing and the application of lotions prior to lovemaking will make the feet softer, thus increasing ticklishness and also attractiveness. One does not have to be a fetishist to become aroused by the sight and touch of a rosy-soled, bathtub-fresh bare foot. But even those who take special care of their feet may find that the soles are unavoidably more tough than the insteps and pads of the toes. Very light scratching of the nails or of stiff brushes and feathers will be useful here. The heels, often overlooked because they are almost universally prone to callousing, are nevertheless quite sensitive if the proper amount of pressure is applied. Try drawing not only the fingernails, but also your teeth across your lover's heel, and watch the reaction. Toes can be nibbled and licked (the spaces in between are particularly sensitive to tongue-tickling), and the tops of the toes, where fine hairs reside, are quite ticklish in most people.

Armpits: This area is so sensitive that forceful tickling (the poking and jabbing of the artless tickler) can be painful. A gentle touch is always required. Whereas feet are rather far away from much of the action, sexually speaking, armpits are close to the face, the mouth, the eyes, the heart. You can be face to face with your lover, looking into his eyes, softly brushing your lips against his, resting your nipples upon his chest, and at the same time slowly tickling his armpits. This kind of tickling is wonderfully intimate. The question of whether or not to shave depends on your mutual tastes, but armpit hair can be more pleasant to caress than armpit stubble, and may transmit added tickling energy. Feathers and soft brushes are useful here.

Ribs: Here is a place where more forceful tickling can work wonders. A fast attack on the ribs can be devastating without causing discomfort. But be careful, as you can literally drive the breath out of a person by rapid and repeated tickling of the ribs. As with any tickle-part, very light touching here is usually effective. Ribs and sides respond especially well to "the spider technique," in which the fingers slowly perambulate the flesh like the legs of a spider.

Insides of the arms and elbows: Many connoisseurs of ET regard this area as undiscovered territory, claiming that in truth there is no more ticklish part of the body! Soft and steady is the key here. The two main areas of concentration are the undersides of the wrists (merging into the forearms), and the interior of the elbows. Try tickling both at one time and see what happens!

Knees: Like the ribs, knees can be "roughly" tickled to good effect. Grasp the knee between your thumb and middle

finger, and administer rapid pulsations. Move up and down the knee until you find the most responsive place. Then move to the back of the knee for a change of place — feathery-light tickling is what you want here.

Palms: A nerve-rich area, the palms of the hands will almost never respond well to hard tickling. Use soft feathers or the tips of the fingers. Calluses may prevent pleasure from being felt, and some people are simply not interested in having their palms tickled, even though they might like to be tickled elsewhere. But for those who do, elaborately bound fingers and thumbs add to the enjoyment.

Neck: Another very sensitive place, though if your lover enjoys getting hickeys, she may not be responsive here to the lighter touch of the tickler. In women especially, the neck is a good place for kissing and tongue caresses. When using your tongue, be especially gentle and teasing, and see how she responds. Since in bondage nothing should be tied around the neck, place a light object (like the Dixie cups previously mentioned) on the forehead to keep the neck immobile and exposed.

Thighs: Proximity to the genital area makes the thighs a terrific place for concentrated ET. Response varies from person to person, but long sweeping strokes with fingertips or feathers are usually effective. These strokes should begin close to the knee and end just short of the groin. This will keep the ticklee wondering when the strokes will elongate to include brushing against the genitals.

Nipples: Men as well as women can have highly sensitive nipples. Kissing, licking, tweaking, rubbing, may all be desirable

to your lover. But as with the genitals, actual tickling may prove difficult to achieve. It all depends on the individual. If your lover likes the idea of nipple tickling, try the softest brush or feather you can find, and play gently around the aureoles. As the nipple hardens, switch to your fingertips, as these will provide the necessary pressure. But not too much! Prolonging a soft and feathery fingertip touch here may have extraordinary results, but too much pressure will activate the mainstream sexual response, especially in women. Nothing wrong with that, but it does take you beyond the ET experience, which you may still wish to explore.

Genitals: Yes, sometimes these are hard to actually tickle because they tend to respond to a firmer touch. But not always. No doubt your partner has spent his entire sexual life having his cock rubbed up and down and vigorously sucked, or her cunt penetrated over and over, and her clit pressure-rubbed with a firm finger or tongue — all wonderful, of course! But perhaps she is ready for something different — the tip of feather on her clit. Maybe he'll go completely bananas if you start to tickle his taut, sperm-crowded scrotum. You won't find out unless you give it a try.

5 PROBLEMS AND SOLUTIONS

Indifference: If your partner is bored by the idea of tickling, you definitely have a challenge on your hands. To better understand where your lover is coming from, fantasize for a moment about whatever it is that really turns you on (ET — what else?), and then abruptly inject the fantasy with an image of some form of sex-play that leaves you cold. This might be spanking, rubber fetishism, some kind of elaborate role-play. (She's a maiden in distress, you're Scaramouche.) Whatever it is, you now see the problem. But take heart, for there is a solution.

The answer is simple: orgasm. If you are mutually attracted, if you are already a couple, if you are in love, (and if you are not burdened by a real sex problem, like absolute, narrowly focused fetishism), then you will certainly have found ways to get each other off. So begin by focusing on the concept of the orgasm. Explain that yours will be exponentially magnified by foreplay involving ET. And further explain that you will be so thankful for the

upgrade that you will be frantic to do whatever it takes to give him a similar boost. From that point, concentrate on modifying any aspect of ET that might dovetail with your lover's sexual interests. For example, most people these days find bondage pretty exciting. So play at bondage games, and introduce the element of tickling as a sideline, just another aspect of dominance and control. Wax philosophical; arouse her curiosity by exploring the relationship of caressing (which just about everyone likes) to tickling. Hands-on experimentation may produce surprising results. If he is really attracted to you — or better yet, loves you — his indifference will slowly become an interest in pleasing you as best he can. At that point the key becomes balance. You have struck a spark, and there is every reason to believe it can become a steady flame. But don't try to turn it into a bonfire. In your obsessive search for more logs to throw on the fire, you might smother it.

Aversion, sad to say, is another matter entirely. If ET makes you hot but your partner is repelled by it, you are probably not a good match. If you are hopelessly in love with each other, then the problem is indeed serious, for being at odds sexually can ruin even the most tender loves. But never give up. Compared to more intense differences involving such practices as coprophilia or hard-core S&M, your problem is small potatoes. By being mutually committed to overcoming your difficulty, you have taken the most important step. Now seek the counsel of a good kink-positive sex therapist, and always remember that your interest in ET is completely harmless, just as you bear in mind that your lover's aversion to it is by no means a judgment of you as a person.

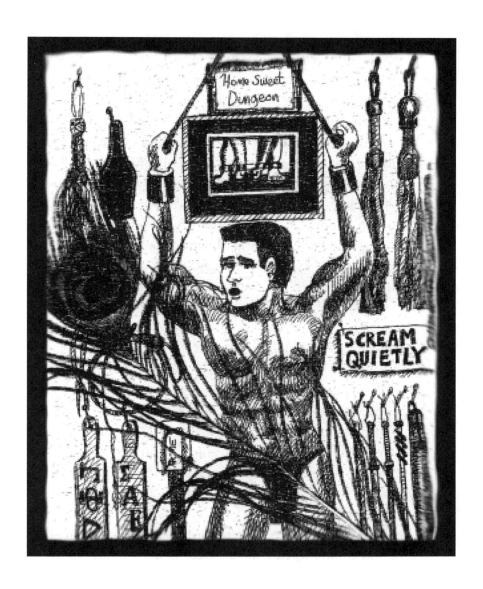

Extreme ticklishness: Very common, and fortunately very fixable. If a person is outrageously ticklish — if even the *intent* of tickling makes her shriek like a banshee — then consider the amount of raw material you have to work with. She is obviously not indifferent to tickling. Here you must determine that she is not averse to it. The person who despises tickling will usually react to it not by laughing and shrieking, but by grimly, angrily repelling the advance. "Cut it out!" accompanied by a hard stare and a frown worthy of a tax auditor will tell you there is nothing here to work with. Move on. But if she dissolves into screams and giggles, even as she is telling you that she really, *really* doesn't like it, there is an excellent chance that she just doesn't know what she's missing.

The worst thing to do at this point is to continue the tickling. Sure, go ahead and tickle her until she wets herself, and see how long it takes before she'll even let you *touch* her, much less introduce her to the joys of ET. No, what you must do now is be exceedingly gentle and sensitive. Her laughter is a sign that she is enjoying herself, but her shrieks are telling you it's too intense. This is a door flung wide open. Your hands that have been tickling her ribs should now move to her breasts. It's exciting to be tickled, and that excitement easily becomes sexual. Most likely her ticklishness will be neutralized when you activate her sexual response, and you should be able to knead and caress her thighs and ribs. But to stray into a highly ticklish area now would probably be a mistake. A finger in the armpit might be too much, and the conscious mind could override the pleasure being felt elsewhere.

For this person, fear of tickling is in the mind. So the first order of business is relaxation. Start with a foot massage. If he has ticklish feet, he will be astonished to

learn that your hands can manipulate his soles and in-steps without causing him to draw them back in alarm. Gentle massage will quiet the nerve endings, and after a while you can try a light caress. If this technique is successful, you are well on your way to Tickle Heaven. Once he realizes that tickling is largely a mental process, he will see that he can control his response to it with his mind, and so can begin an exploration of the physical intensity that he has always felt while being tickled. As with anything, understanding is the way to end fear.

When you have reached this point, try the same thing with other tickle parts. Any part that does not respond well to massage (armpits, for example) should be left for the next stage, which is the establishment in your lover's mind of an association between sexual pleasure and tickling. This is accomplished by slow and gentle exploration. Proceed by working her into a lather with whatever sex techniques you normally employ. Then, when she is on the verge of coming, begin the experiment. (You will have to agree on this beforehand, or she'll cry, "What the hell are you doing? Get me off, dammit!") One hand should be concentrating on her cunt. Your finger — index or middle, it doesn't matter — has entered her gently, and your thumb is rotating on her clitoris. She is well-lubricated and heaving. You have established exactly the right balance between a slow in-and-out movement of the finger and a soft teasing of the clit. Occasionally you stop your finger, leaving it to press lightly upon her G-spot, but persist in the rhythmic stroking of her clit. (And remember, where the clit is concerned — gentle, gentle, gentle.) Then you alternate, moving your finger in and out again, but stopping your thumb, allowing it to rest on the clit, which it tortures by its inaction. When you employ both

the finger and thumb at the same time, she is just about ready to explode, and that is the moment to put your other hand in motion. You have already agreed upon where you will tickle, and you have established that your tickling will be slow and soft, and that you will stop if she asks you to. So now place your fingertips in her armpit, and slowly tickle her there while you decrease the movement of your other hand. As you alternate between armpit-tickling and cunt- teasing — first one, then the other, then both at the same time — you should begin to see that the barrier that has separated tickling pleasure from sexual pleasure is finally crumbling. If this is indeed working, and if she is able to resist the orgasm, move your tickling hand to another spot — her ribs, her knee, even her foot, if she will bring it close to you. Throughout all of this it is essential that you explain what you are doing, that you are trying to connect the two types of pleasure, and that this is a tremendous turn-on to you as well as a monumental exploration, for you don't know what surprises may be in store. By talking about it, you keep her mind engaged while reassuring her that the tickling is part of the sex.

If you are doing a good job, you will soon — very soon — reach the most crucial moment of the experience. One misstep here can undo much of what you have already accomplished, so be careful. Spurred onward by your expert teasing and tickling, she has reached the summit of Mount Orgasm, and is ready to plunge into the delicious, throbbing void of sexual free-fall. As I have pointed out earlier, some people find ancillary tickling at the point of orgasm to be distracting, even unpleasant. And if your lover is already super-ticklish (which, after all, is why you have been acting out this scenario) she might revert to

that state at or immediately after reaching her climax. This is indeed a "ticklish" matter. It will require every bit of your skill and attention to give your lady a powerful orgasm while figuring out whether continued tickling will enhance or ruin the moment for her. Two things will help you here. First, establish beforehand that if she wants the tickling to continue she should blurt "tickle," or some other agreed-upon word, even as she is bucking and heaving. This effort is a small concession to disturbing the purity of the moment, especially as it will increase her pleasure. But if she is reluctant to talk about this at such length ahead of time — if she considers it too programmed — then you must rely on the second tip I will now give you. Simply this: Stop the tickling at the point of her climax. Remember, this is a highly ticklish person you are dealing with. In all likelihood she has already had her fill of tickling. Let her concentrate on the orgasm. When she's finished, she will inform you if she wants more tickling at any time before, during or after the big O. You can count on it.

Obsession/fetishism: ET will bring joy to any couple who give it a shot, but if one partner becomes obsessive, there is trouble ahead. The amplification of sensual pleasure before and during the orgasm will have a powerful effect on your libido. If it's so great, then why not experience it every time you and your lover connect? And truly, if both of you are happy and satisfied with your sex life, there is no earthly reason not to indulge in ET as often as you wish — hell, two or three times a day! — as long as your bodies can take it. But the danger lies in becoming jaded. As a distinctly sensual pursuit, ET puts you in touch with an intensity of pleasure you may never have experienced.

More, I want more! cries your libido, and you can lose sight of your partner as a human being. She becomes a tickle machine, existing only to tickle you or be tickled by you. This is a drastic response, but it does happen. The solution here is sanity, common sense, and sensitivity. Expect to become a little jaded, and so limit your ET sessions accordingly. Remember that in addition to being tickled, she also likes to be kissed, and cuddled afterward, and without being tickled every blessed time. And don't forget that although he loves it when you tickle his feet, he might prefer it if once in a while you gave equal time to fellatio.

Fetishism occurs when a body part or an object used during sex becomes the absolute focus of the libido. This is most often a guy problem, but it becomes the partner's problem when he literally cannot get or stay hard unless he's sucking on your toes or feverishly tying you up with the official Lone Ranger lariat he's had since he was nine. Professional help is needed in extreme situations. For example, the typical man who is "into feet" and considers himself a foot fetishist is more than happy to consider alternatives. He is attracted to your feet — he wants to caress them, kiss them, tickle them — but if they happen to be covered with poison ivy (yikes!) you can still have sex with him if you want. Indulge the fetishist — give him plenty of what he likes, and plenty of what you like too — and you can't go wrong.

Infantilism: Infantilism (a very specific diversion contained within the category of age-play) is the practice of acting like a big baby during sex. No, I'm not talking about your last boyfriend who whined and cried when the sex wasn't all he thought it should be. I'm referring to men who long to

be diapered, pampered, given a bottle and a blankie, and, well, treated like a big baby during sex. Some women will find this scenario just too silly for words, while others will have their maternal instincts aroused and participate fully in the fantasy. (Are there women infantilists? My investigation of infantilist literature and websites suggests that they are fairly rare. Women age-players, however, are more common; some enjoy playing the role of a very young girl.)

Infantilism is only a problem when the female partner is struck by a kind of aesthetic dissonance at the sight of a grown man wearing a bonnet and diapers. Infantilists must hope for a partner with a sense of humor and a childlike wonder at the astonishing variations of human sexuality.

What does this have to do with ET? Well, a man who likes to be tickled might harbor a secret fantasy of being a helpless infant in a crib being tickled and tickled and tickled by a cruel nanny, so don't say you haven't been warned. What to do if this is a problem? Not much, probably, except to go with the flow and keep telling yourself that infantilism is about as harmless as a kink can be.

Unilateral sadism: This happens when one partner wants to tickle the other to a point where pleasure becomes pain or extreme discomfort. In a D&S or S&M relationship it is almost always the submissive who sets the limits. If your partner wants to tickle you beyond those limits, until you weep or wet yourself, the experience can become abusive. Using a safeword should prevent this from happening. Both partners must agree prior to the ET session that when the safeword is used, the tickling will stop. Choosing "color" words like yellow and red is an excellent idea — yellow meaning that the tickling is getting too intense and

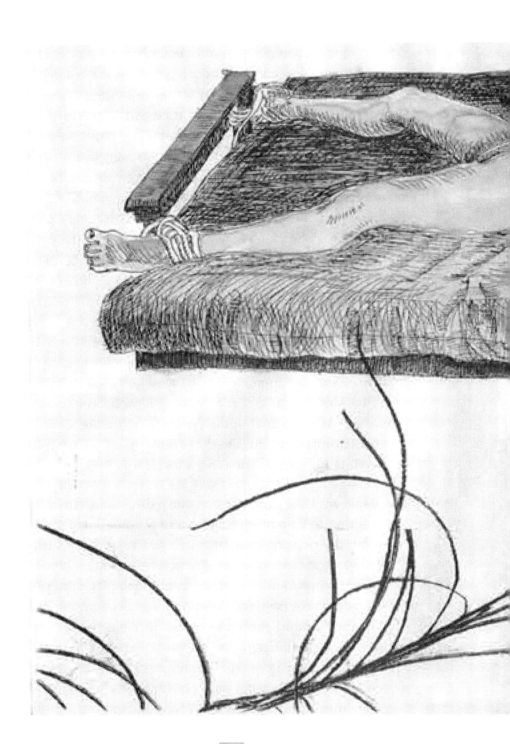

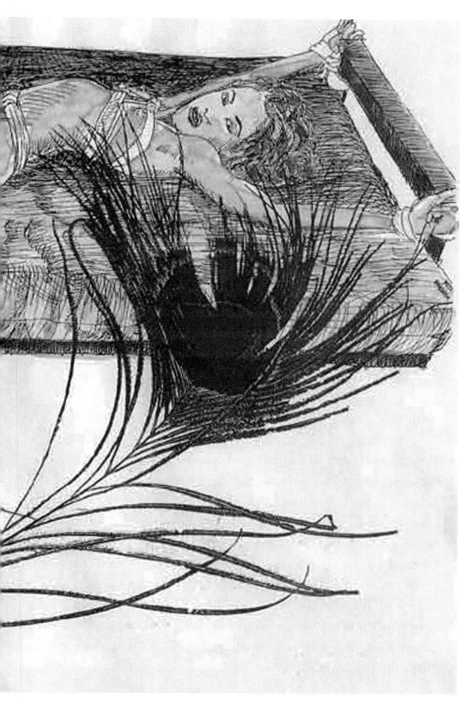

should be taken down a notch, red indicating that the ticklee has reached the limit of comfort and wishes to be untied at once. When a submissive is gagged, a non-verbal safeword is necessary. This can be a code of grunts (three short bursts, for example), the snapping of fingers (unless they're tied), or perhaps the humming of the first bars of "Yellow Rose of Texas."

If the tickler ignores a safeword, he obviously cannot be trusted. Abuse by tickling is no laughing matter, and your untrustworthy tickler may escalate to even worse forms of abuse during future sessions. My instinct would be to flee any relationship in which my partner subjected me to actual cruelty, and I advise you to follow suit. However, it is possible that a decent person might go a little too far in the heat of passion. If this happens, and if the person is otherwise stable and good-hearted, there is probably room for discussion and education. But unless you are absolutely certain that your lover will never do this again, that this was a one-time aberration, you are playing with fire.

Drugs: A word on the use of drugs is appropriate here, as so many of us are in the habit of altering our minds when we make love. It is my belief that almost all drug use is ultimately detrimental to the human entity. While it's true that in some cultures the use of psychotropic substances during rites of passage produce benign effects, in our Western society the result of drug taking is more often addiction and wasted lives. As a veteran of the drug heyday of the early 1970s, I feel I have license to make that statement; many a good soul of my acquaintance fell by the wayside after too long an indulgence in drugs.

Having said that, I will admit that certain stimulants, if used moderately, may enhance the sexual experience, including ET. Pot is a benign herb and a favorite of many sensualists. Some users swear that pot can enable the smoker to focus more easily on the sensation of the moment, effectively blocking out all distractions and thereby intensifying the orgasm. Others are made paranoid by smoking pot, hardly a state of mind conducive to the enjoyment of being tied and tickled. Cocaine, despite its purported aphrodisiacal powers, is dangerously addictive, and should never be taken, even if offered to you on the extended, scarlet fingernail of a leather-clad tickle-dominatrix who will not otherwise pleasure you. Such is the author's opinion. It is also useful to remember that these and other stimulating drugs are illegal.

Alcohol, quite legal in our country regardless of its proven murderous potential, is seldom a good choice for use during a tickle session. As a depressant, it quietens the nerves, and flesh that yearns to feel the titillation of dancing fingertips may be disappointed at the dullness occasioned by booze. On the other hand, an hysterically ticklish partner who is reluctant to try ET is an excellent candidate for a few preparatory sips of wine. Her normally jumpy nerve endings will be lulled into a hammocky acceptance of light tickling.

Drug or drink if you must, I suppose, but also consider the value of a mind unclouded in any way, and able to wrap itself around the ET experience with utter clarity and a concentrated attention to all the supersensual, tickly details.

6 A FEW SCENARIOS

For the devotee's delectation and fun, here are some ET role-playing scenarios, placed in four distinct categories:

Extraction of information: Since tickling is often perceived as a method of torture, sometimes even by those who enjoy it, this scenario is a natural. Particulars may be borrowed from any book or film or TV show with a scene in which a man or woman is tortured into revealing something hidden. A beautiful spy, knowing the whereabouts of an Underground hideout, is captured by the Nazis. When the Gestapo lieutenant gets a look at her, he dismisses his underlings and decides to conduct the torture by himself. Stripped naked, his alluring captive is bound upon a leather table. (If you're in bed, just pretend.) He explains to her that although he must torture her for the information, he is so taken by her beauty that he cannot bring himself to desecrate her flesh with cuts or

welts. Therefore, he is going to tickle her until she loses control and reveals her secret. He must apologize, he continues, because he understands that ordinary methods of torture would yield results more quickly, but as a lover of beauty he must implement tickling and nothing else. If a scenario involving Nazis is offensive to you (quite understandable), simply substitute a Kremlin commandant or any other totalitarian type for the Gestapo guy. If you can find or make them, costumes will add much to the scenario, as will any accents appropriate to the ethnicity of the tickle-torturer. In addition, a gag might be usefully employed. The victim thus has a limited span of time to reveal the information; once the gag goes back in place, she must wait until the next opportunity, and in the meantime will be tickled with no chance for mercy or cessation.

Here's another one. A gang of eco-terrorists has kidnapped the CEO of an oil company, and require that he divulge the location of a newly planned oil dig, so they can go there and sabotage the equipment. Since eco-terrorists would feel like hypocrites doing harm to any living thing, they cannot think of how to proceed. But one of the leaders, a fringe-wearing, moccasin-shod tickle-sprite who is half Crow Indian and thus mindful of the depredations of big business upon the land, knows exactly what to do. Leave him to me, she says, and I will tickle him to near insanity by alternately using feathers from my headdress and my very sharp fingernails. The CEO is thus tied to the four points of the bed, and the sadistic Indian maid begins her work, after first getting naked for the occasion (why not?) except perhaps for her beads and bracelets.

Tickle-torture to get information can be applied to *any* situation. Babysitter tickles her charge to find out

where the parents hide the key to the liquor cabinet. Enraged wife tickles her husband to learn the identity of his trollop. Cruel sultan tickles harem girl to discover which of his courtesans have been dallying with the eunuchs. Simply use your imagination.

A devilish variation of this scenario occurs when the tickle-victim is innocent, when he *has* no secrets to divulge. Now the tickler must satisfy herself that the ticklee is telling the truth, and this will take considerable time and ingenuity.

Punishment: Here the tickling scenario is very straightforward. The victim has done something wrong, and must pay for it by being tickled to exhaustion. A UPS man is tricked into bondage by a seductive businesswoman in a severe tailored suit, high heels, and black-rimmed glasses. He is expecting a fast blow-job, but when he's helpless the woman whips off her glasses, lets down her bunned hair (just like in the movies) kicks off her high heels, and begins to savagely tickle him because he was late with an important delivery. A gruff cowboy lassoes the town's uppity schoolmarm. Her fury is unregenerate, so he decides to tickle her into submission. Bound on her feather bed, she finally succumbs to the torment, yielding willingly and wetly to the range rider's vigorous thrustings.

Women, by the way, may not require four-point bondage as often as men. They may only need to have their hands bound behind their backs, and their ankles tied together, if even that. Then they can be carried to a bed or sofa where their he-man will simply overpower them with his superior strength. In most tickle fantasies where the man is dominant, the ending should include a revelation that the woman is so sexy and adorable that the man has fallen

hopelessly in love with her. The tickle-torture was necessary, but now they can ride off into the sunset together.

Men, being what they are, will not seek such a *denouement*. Although they will require sturdier bonds — lest by sheer muscle power they break free — once the orgasm has been achieved, it's time to get untied and order a pizza.

Therapy: For those who wish to avoid a D&S scenario, therapy might be the answer. No, not actual therapy to eradicate all desire for ET play, but the made-up kind, in which a disturbed person is being "helped" by, say, a new-age therapist who employs tickling as a means of breaking down neurotic resistance.

In a candle-lit room, with softly tinkling chimes and new-age music and incense all part of the ambience, the poor, confused woman is told to lie down on the cot and stretch out her limbs. Is this for a massage, she asks? Well, says the therapist, not exactly. He then explains his theory: most neurotics are victims of sexual frustration, and their bodies are rigid with what Wilhelm Reich called "sexual armor," and the best way to dispose of this armor is to be, um, tickled. Did you say *tickled*, she asks? Oh, that won't work with me. I'm far too ticklish to stand such therapy. I would scream with laughter and flail at you. Exactly my point, says the therapist. Such an extreme reaction to something as gentle and harmless as tickling indicates a serious problem. You are indeed an ideal candidate for this therapy. Well, she says, I don't know… Look, he says, tell you what. Why don't we tie you to the cot? That way you can struggle all you like, and the therapy can continue regardless. After some more convincing, the future tickle-victim agrees to be tied to the cot. First she is

told that she must be naked, however, so that the therapy can be most effective. Finally, as she is bound and helpless, the therapist produces a gag. What's this, she asks? You didn't say anything about a — . Sorry, he says, when she is no longer able to speak. Part of the therapy, don't you know. See, now you can scream and laugh at the top of your lungs, and no one will hear you. Best way there is to shed that pesky sexual armor. Now let's see, where shall we begin? Say, I'll bet those pretty feet are incredibly ticklish. Let's find out!

And so on. A quick perusal of New Age literature will give you plenty of ideas for the fleshing-out of this scenario. Like all "movements," New Age has its storehouse of conceptual knickknacks, from which an imaginative lover can withdraw various items for the enhancement of tickle-play. The chakras, for example, those invisible wheels of energy situated along the body from the third eye to the perineum, may require an opening-up through a special type of tickling — clockwise movements of the fingertips, erotic reflexology, the chanting of a mantra while a feather slowly torments the genitalia... who knows what it might take to get those recalcitrant wheels spinning the way they should?

For intellectual types who disdain the New-age movement as a refuge of bliss-ninnies, the traditional psychiatric setting can be used for a therapy scenario. A voluptuous psychiatrist is treating a patient for erectile dysfunction. During the treatment she learns his secret: as a child he was tied down by a playful older sister who tickled his testicles to near-explosion and then used his erection for her pleasure. The only cure, she explains, using a lot of psychiatric mumbo-jumbo that makes no sense whatsoever (but who cares?), is for the two of them

to re-enact the incest scenario, but this time with a payoff not including sex with an older sister. Of course, when she has the man tied to the couch and writhing during the testicle tickling, she is overcome by a sadistic urge to tickle him in other places as well, and to prolong his orgasm far beyond what he might have expected. As a trained psychiatrist, she understands the dangers of repression, and so indulges this cruel whim, heedless of the man's cries to be released from the torment of pre-orgasmic suspension. Naturally it will be her turn next.

Exotica: This refers to any scenario involving faraway places, mysterious lovers, strange or unusual settings. A jungle explorer, you have chanced upon the lost city of Tickelopia, populated by a dying race of beautiful women, and are taken by the scantily clad minions of Queen Tortura to the royal bedchamber. It is written in the Tickleopian Scriptures that their race can only be perpetuated by the energized sperm of a man in the throes of tickle torture. Since you're the only one with a penis within thousands of square miles, you're in for a wild night of intense tickling ending with the impregnation of the Queen.

A solitary woman traveling on business in a foreign country, you are kidnapped by government agents and delivered into the hands of a mad scientist for a fiendish experiment. He has convinced his superiors that he can induce astral travel (which might be studied and later used for the purposes of spying) by subjecting a victim to torments so acute that the soul is literally forced to escape from the body. Thus far, the implementation of actual torture has resulted in some interesting results, but each time the victim has died from the ordeal. Not unlike the

Gestapo lieutenant of an aforementioned scenario, the scientist has had the brilliant idea that a very ticklish person — a woman, ideally — might be so tortured by feathers and fingertips that the same result could be achieved without the victim's death, allowing for further study and experimentation on the same person. The scientist, who has carefully studied tickling in every aspect, is a believer in a hands-on approach, and so it begins.

These are rather extreme scenarios, conjured by a lonely writer who has nothing to play with but his fevered imagination. You may prefer a milder approach to exotica. A gentle tryst with a native girl on a south sea island, whose culture has practiced the tickling arts for centuries. Tickling games with a handsome Italian count in his Florentine villa, prior to spirited copulation and a proposal of marriage.

One caveat regarding exotic scenarios: too much reliance on these may not be healthy. Images of handsome noblemen or dusky native girls are not sustainable, and eventually you must deal with, and be satisfied by the reality of a partner whose face and form may never grace the cover of a romance novel. Be happy he or she loves you, and loves to tickle you, and save the exotica for special occasions and dim candlelight.

CASE HISTORIES

lthough this book is not intended as a psychological study, the following case histories should be of use to the casual reader interested in ET. I have no background or training in psychology, nor do I claim to be a scholar, so these are loosely presented in a narrative fashion. They are simply the stories of two people who are sexually aroused by tickling.

Lisa. A 37-year-old nurse living a large city in the Midwest, Lisa did not come to an appreciation of ET until her mid-twenties. She describes herself as a "sensation junkie," and has been actively involved in the D&S scene since divorcing her husband, a dominant man who tickled her only once during their marriage, and not very satisfactorily. "He was heavily into master-slave role-playing, preferring always to be in control. Since I'm mostly a submissive, that was fine with me. I like the intensity of pain. My husband would tie me down and whip

my ass until it was red and covered with welts, and I loved it. Even a little blood flow was acceptable, so long as there was no scarring or serious wounding. I also love having my nipples pinched and bitten. I'm polyamorous, and some of my current lovers are reluctant to inflict pain on me, especially in a place as sensitive as the nipples, so I have to reassure them that it's what I want. I don't think that what I experience is pain in the truest sense. If the dentist drills a nerve, for example, I'm out of the chair in a flash. *That's* pain, and I'm not into it at all. Maybe it's all a matter of where your threshold is. For me, it's pretty high."

Lisa's first orgasm, however, was not pain-related, but tickle-related. "My cousin Brenda used to stay with us sometimes in the summer. We were thirteen, good friends, and very close physically, in a way that seemed perfectly appropriate. We would hug and kiss on the cheek, and late at night when we watched TV we started experimenting with sensation. She started it first, I think. She had this "test" that some girl at her boarding school had shown her. You had to hold your arms out flat on a table and let someone lightly draw her fingertips up from your wrists to the insides of your elbows, and back down again. The person who could stand the most repetitions of this was the winner. It sounded like fun, so I decided to try it. We were on the couch in the rec room, so I lay on my stomach and stretched my arms out across her lap. 'Now hold still,' she said. 'If you move at all, you lose.' The movement of her fingers was really slow and teasing, but I knew right away that I would be a champ at this, because it felt great and I didn't want it to stop. I had never masturbated and knew almost nothing about sex, so I felt confused by the feelings of arousal I started having. I remember get-

ting really wet, and being almost paralyzed by a throbbing sensation in my vagina that was new to me. But even though I felt confused and a little ashamed, I didn't want it to end. I was glassy-eyed and not saying anything, and Brenda said I was doing really well, but that I had to endure a tougher test. She had me lie on my back and put my legs on her lap. I was so caught up in the pleasure that I didn't hesitate for a second. I was barefoot, and she started caressing my toes and the soles of my feet, which felt better than I ever expected it would. She kept this up for I don't know how long, while I lay there like a statue with probably a totally goofy look on my face, and then she started moving her fingers up my legs, to the insides of my thighs, where she stayed for a long time, tickling them with her fingertips and also her nails, which weren't very long but did the job. By this time I was going crazy, and starting to writhe around a little, and before I could stop her she snuck a hand up the leg of my cut-offs and started rubbing my clit on top of my wet panties. I remember thinking that this wasn't right, but I let her continue. This was all new to me, and it only took a few seconds before I had this incredible orgasm while she rubbed my clit and tickled the inside of my thigh at the same time. As soon as I had that orgasm, everything changed for me. I was dimly aware that there was something secretive about sex, and that people of the same sex shouldn't be together in that way, but after feeling such joyful physical pleasure, I couldn't believe that what we had done to cause it was anything but good. Brenda asked me to do some things to her, and I went along with it. She gave me her feet to tickle while she did herself. I didn't mind tickling her feet at all, since they were small and pretty, and the bottoms

were soft even though she went around barefoot a lot. I was fascinated to watch her reactions as I continued tickling her and she got closer and closer to her orgasm, moving her fingers in a rapid circular motion on her clit. In a breathless voice she asked me to move up to her thighs, which I did, and she came like crazy, bucking forward while she moaned with her eyes closed."

For the rest of that summer Lisa experimented in this way with her cousin, learning all she could about her responses and discovering that tickling sensations greatly aroused her. A few years later when she started going out with boys, she found that their interests did not lie in the soft, sensual activities she was used to. They tended to be aggressive and quick to the chase, but this posed no problem for Lisa, as she found rough handling every bit as sexy as the teasing she had enjoyed with her cousin. By the time she was in college, she knew enough about herself and about sexuality in general so that she allowed herself to go for men who were dominant and capable of giving her what she craved. For five years she enjoyed an active D&S sex life with her husband. As she became aware of a D&S subculture involved with tickling, she asked her husband if he might like to experiment with it, and he complied. But he proved not to have a talent for ET, being so assertively dominant that any light tickling struck him as silly, and he would revert to rough poking and prodding that straddled the line between the paradises of soft pleasure and the refinements of pain, and so left her bored. The marriage ended for a variety of reasons having nothing to do with her husband's ineptitude at ET, and Lisa moved on to the single life and its many curiosities. A petite brunette with small breasts, lovely legs, and a pretty face (people have told her she looks like the actress

Sally Field), Lisa has no trouble attracting men. Gradually she has woven ET into her active and satisfying sex life, and has one lover in particular who fills this need for her.

"We both like being bound and tickled," she says, "and that's okay with me, even though I'm primarily a submissive. I have another lover who likes to be dominant, so when I see my tickle guy, I'm in the mood for a gentler scene. Usually I tie him up and tickle his sides and armpits while he's in me. I warn him that he'd better not come until I give him permission, and if he does, I'll tickle him without mercy. Since he doesn't like to be tickled after an orgasm, this is a warning he takes to heart. One time I made him so crazy that he came before he was allowed. I hadn't gotten off yet, so I was pissed. He begged me to untie him, but I wouldn't. I felt it was necessary to make a point, so I tickled him without mercy for about ten minutes straight. I suppose he might have liked it a little — he *did* get hard again toward the end — but I know that it was pure torture as well. And the point was made. He's *never* come prematurely since then, no matter how much I try to tease him into it."

Although her "tickle guy" (whom we shall call "Teddy") is a sub at heart, his understanding of the tickling arts, and his gratitude for the pleasure he receives from Lisa makes him a wonderfully dominant tickler as well. "I think it's because he's so intensely into being tickle-tortured that he's so good at dishing it out," says Lisa. "My feeling is that the greatest masochists in the world also make the greatest sadists, and vice-versa, because they've obsessed so much on the little details of what's involved. Teddy just *loves* to have his orgasm prolonged while he's suffering tickle-torture, so he knows exactly how to put

me through the same ordeal. And I couldn't ask for anything more, since probably my biggest sex-thrill is being told I'm not allowed to come without permission. That drives me completely crazy. Teddy knows this, and so he makes it clear from the get-go that if I come before he's allowed me to, he'll punish me in the way I hate the most, which is to be completely ignored while I'm bound. I really do hate that, so I've never given him the opportunity to inflict this punishment. I think he'd do it, too, because he *does* have a little bit of the sadist in him, like every masochist. In fact he's described to me how he would do it. He says he'd leave me tied to the bed and go into the other room and watch a half-hour sitcom, and if I made a peep he'd come in and gag me and then watch another half-hour's worth. Of course while he told me this he was teasing my clitty with his fingers and tickling my nipples with a stiff goose feather."

Lisa may require more than tickling for her pleasure, but she has this to say about her lover's expertise at ET: "I have to admit that Teddy gave me the best orgasm of my life. I can actually pinpoint it. It was a warm autumn night, and that was a turn on itself, because the warmer it is, the more alive your nerve-endings are. I was spread-eagled to the bedposts and Teddy had been working on me for quite some time, tickling me all over and only occasionally brushing my clit and vulva with his tickling fingertips. I had already done him in, ending up with a pretty good orgasm for myself while I rode his exploding cock as he groaned and strained at his bonds. But now I was ready for another one. I was sweating and my slippery skin felt excruciatingly sensitive to his fingertips, and I had already begged him a number of times if I could come, because every time he touched my clitty, I almost lost it.

That's when he told me that this was going to be a night I would remember until the day I died. That was sexy thing to hear, but I didn't realize how true it would turn out to be. He had been kneeling on the bed beside me, tickling my sides and groin, and now he repositioned himself so that his face lay between my thighs and his hands reached up to my armpits. I moaned in anticipation, because my armpits are usually my most ticklish area. He started right in on my clitty with his tongue, using different pressures and movements, sometimes licking it avidly like a dog, then alternating with light, teasing flicks. And all the while he proceeded to tickle both my armpits without mercy. In his expert way he knew that the lightest touch there would be the most erotic, and it was only a minute or two before I was literally screaming to be allowed to come. That's when he made it even more intense, though I wouldn't have believed it possible. He moved his hands so that his fingers were tickling the middle of my armpits, and each of his thumbs was tickling my nipples and the upper part of my ribcage. And with his tongue he started to concentrate on one steady, sinuous teasing lick that he did *very* slowly. I had never been in the hands — or I guess I should say tongue — of such a cunnilingual artist. He stopped licking me for a moment (although he did *not* stop tickling) so that he could tell me what was coming next. This would be a series of counted clit-licks, beginning with ten, and then, after a twenty-second pause during which he would lick and kiss my thighs and cunt-lips, he would begin again, adding increments of five more licks each time. I begged him not to do this. I said I was literally on the edge of coming, and that I could not possibly hold out any longer. But he was merciless. "You'll simply have to, my dear," was all he said. And then he started the real

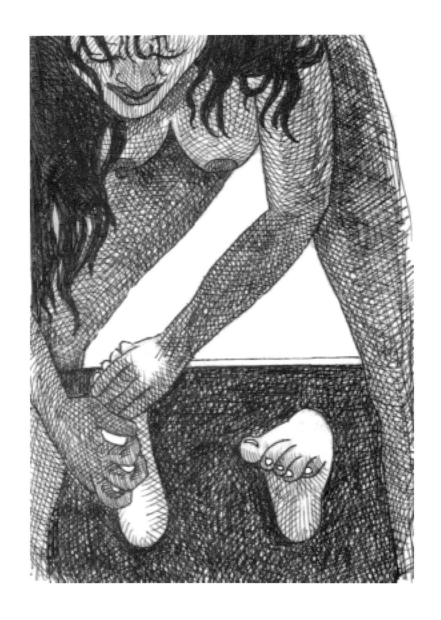

torture. The tickling was non-stop and almost unbearable, and throughout he forced me to count each clit-lick out loud, even though I could barely catch my breath. I don't laugh when I'm tickled, but I do groan and gasp a lot, and so counting out loud was a real struggle. But I had to do it. I had to obey my Tickle Master. I counted to ten, and then fifteen, and so on, and each time he pulled away from my clitty to kiss and lick my thighs, I had to count those twenty seconds as well. We were up to fifty when he said I was doing well and now could move on to the next stage. I was too dazed with pleasure and anguish to respond, but when I realized what he was up to I begged him to stop. He took away one of his hands — which seemed a relief at first — but then he used the middle finger of that hand to gently penetrate my vagina and start working on my G-spot. And that was it. He rubbed my G-spot, licked my clitty, and tickled my armpit, nipple, and ribcage all at the same time. Diabolically, he would stop from time to time, although never the armpit tickling. He told me to keep counting, but I just couldn't. All I could do was howl out a continuous plea to be allowed to come. *"Oh God please let me come, I have to come now, please, please master let me come, Oh please I can't stand the tickling anymore, please let me come Tickle Master, please, please…!* And finally, after what seemed like forever, he lifted his face long enough to tell me I could come, and at that instant I almost blew apart in ecstasy, screaming like an animal in the jungle, and pulling at the leather straps around my wrists and ankles so violently that I thought the bedposts might buckle. Teddy knew what to do then. He stopped all tickling and teasing just as my orgasm was ending, and tenderly kissed my throbbing cunt, and then immediately untied me and began to massage my wrists and ankles,

and then fell beside me and held and caressed me while I slowly came back to earth."

Lisa has enjoyed many other ticklegasms with Teddy, and while none have been quite so strong as the one just described, she looks forward to more attempts at duplication. "Teddy joked that he's going to invent a chin-dildo, so he can penetrate me while he licks my clitty and tickles me with *both* hands. I told him it shouldn't be a joke. Please do invent it!"

Lisa is so grateful for Teddy's loving attentions that she is forever trying to think of new ways to pleasure him and feed his tickle fantasy. "Recently I propped myself at the foot of the bed and tickled both of his feet while I slowly masturbated him with my own feet. First I smeared his cock with Vaseline, so that my feet and toes would slide all over it, and I could tell by the tightness of his scrotum when he was ready to come, so naturally I would stop rubbing his cock and rest my feet on his belly so he would have to stare at their pretty soles and arches while he begged me to continue. I'm a skilled foot-tickler; I know how to alternate my long fingernails with my soft fingertips, and what parts of Teddy's feet are most vulnerable to each, so I really had him going for a long time. He came so hard that he shot his stuff almost up to my navel!"

I asked Linda if her interest in tickling could ever replace her desire to play other, more intense D&S games, and she said no. "I love tickling, but I need stronger sensations in my life. I'll never stop wanting to be punished with pain. But I'm really happy that I can add tickling to the repertoire. I'll be a tickler and a ticklee for as long as I'm interested in sex."

Michael. At forty-nine, Michael has enjoyed for many years an excellent and unusual career as a recruiter of college age students who seek jobs as nannies, tutors, and camp counselors. He is constantly traveling through Europe, South America, and Asia, and became a man of the world at an early age. Handsome and well built, he has enjoyed liaisons with many beautiful women, and he believes that his movement through various cultures has enabled him to find partners who share his tickle fetish.

"I've known I was a tickle fetishist forever," he says. "When I was ten, my older sister held me down while two of her friends tickled my feet and my ribs. I'll never forget the sensations that came over me. All I wanted to do was lie there and enjoy it, but I knew that when you were tickled you were supposed to scream and struggle, so I put on a decent show and they kept it up for as long as it took me to have the first orgasm of my life. That part of it started out uncomfortably, because I was trying to hide my erection from them, and when I started to get close to coming — which I knew nothing about — I thought I would urinate in my pants. But I just let loose and shot in my skivvies, and then I didn't give a crap about anything. I stopped struggling and they stopped tickling and let me up off the floor. I think my sister, who was fourteen, knew something had happened, because she called me a creep and didn't horse around with me after that, although we have a fine brother-sister relationship today. Well, after that day I started paying attention to everything I ever saw or heard about tickling. I had always been fascinated by tickling scenes in movies and comic books, and once when I was about six or seven I had a dream in which Supergirl was tickling my feet for no particular reason. I woke up with a giant erection and a full bladder, and had the damnedest

time peeing. When I was older I got hold of a paperback copy of *Psychopathia Sexualis*, and that was a real eye-opener. Most everything in the book struck me as bizarre, but when I came upon a description of a man who enjoyed licking the bare feet of servant girls, I felt an incredible desire to put myself in his place, and so I began to think of myself as a foot fetishist. Whenever my friends and I discussed the mysteries of sex, which as teenagers we were beginning to think about all the time, the talk always centered around tits, and sometimes, with the more experienced types, pussy. No one ever mentioned feet, so I correctly surmised that my longings were different and had better be kept under wraps. This would have caused me considerable shame if not for the fact that as a healthy youngster I had enough spunk rising in me so that *any* part of a woman's body could get me off, and when I began to go out with girls I had no trouble having erections and orgasms. I was a good-looking kid, and had a lot of sex even before I got to college, though most of it consisted of feeling a girl up while she masturbated or fellated me. I was fairly satisfied, but in the back of my mind there was always this longing to caress and kiss a woman's feet. Whenever I masturbated, I would think of doing this, and in my imaginings I also wondered what it would feel like to tickle a woman's feet and watch her struggle and laugh. When I thought of this, I would come faster and more powerfully, and so it dawned on me that my interest in feet might actually be more of an interest in tickling. On more than one occasion I'd made out with a girl whose caresses were of a tickling nature, and at such times I became highly aroused. Sometimes I would try to tickle them, but usually they resisted. It was not until I reached college that I found a girl who was really into tickling, though

even with her I never truly opened up and told her how much of a fetish it was for me. Her name was Diane, and she was a tall blonde with fantastic legs and perfect feet. She lived in an apartment with some girls I knew, and I made it a point to visit the place as often as I could. I knew the rules of courtship — knew that to present myself as a fetishist who kept staring at her feet would be a turn-off — and so I played the role of a normal swain, and in a short time we became lovers. I had noticed that she seldom walked around the apartment barefoot, and I took this as a good sign, and indeed it was. She was into pedicures and pumicing and keeping her feet clean and nice because she wanted to have them kissed and caressed. The first time we made love it was strictly vanilla, but during the act I noticed that she rubbed her feet up and down my legs, and afterward as we lay in bed, talking and playing, I offered her a foot massage and she practically thrust her feet in my face in response. To make a long story short, it quickly became clear that we were very compatible, and kissing and tickling her feet became part of our regular foreplay. I found this so thrilling that I was always horny for her, and we had a great sex life. She enjoyed tickling me as well, and I would even go as far as to say that she had the makings of a foot fetish, which I understand is quite rare in women. We experimented with bondage, and she always spent a lot of time tickling my feet while I was tied, which of course I loved. We were so explosive sexually that when we finally broke up for other reasons, we couldn't remain friends, and I never saw her again.

It was a long time after that until I got lucky again and found a woman who was into tickling. For a few years I had knocked around a few cities in the Northeast, flitting from job to job, and bedding as many women as I

could. I would say that about half of my paramours had an appreciation of tickling, but only in a minor way. They liked to tickle and be tickled, and they found it exciting as part of foreplay, but they only wanted to engage in it occasionally, and they didn't spend all their time thinking about it, like I did. And many of them were uncomfortable with the idea of bondage, as it seemed a little scary to be tied up and have somebody — even a man they trusted — tickling them without mercy. A couple of the women I knew at this time eagerly enacted the dominant role in a tickling scenario, and for a while I enjoyed the pleasures of being a tickle slave, but this, too, passed, as the women sought other relationships that did not have tickling as the main component. I knew that there were prostitutes who specialized in tickling, but I resisted this in principle, hoping I would never have to pay for the kind of sexplay I wanted. When I got the job of recruiter, I was ecstatic, thinking that in other lands I might find such a variety of women that some of them would be more amenable to tickling as a way of sexual expression.

While it didn't turn out quite the way I expected it to, I did have a series of relationships over the next few years that involved tickling. A mannish redhead I met in London had a dominant personality, and loved to tickle my upper body while I was standing with my arms tied from the ceiling. Unfortunately she was also a great fan of spanking, which I don't enjoy at all, either as a giver or receiver. A Swedish girl, a classic Nordic blonde still in her teens, was a sensualist looking for every kind of sexual experience she could find, and when I introduced her to the joys of tickling, she took to it like Bjorn Borg to the grass courts of Wimbledon. She was more submissive than dominant, and I had many a wild night tying her to a chair

(her favorite thing) with her feet sticking through the slats to be tickled, and then letting her fellate me. She tired of me, though, and moved on to other men and other things. A Latino fireball from Buenos Aires proved almost too much for me to handle. She had no particular interest in tickling, but loved fucking with an almost insane passion, and when she learned that tickling turned me on, she threw herself into it as a way of keeping me rock-hard and randy for her pleasure. She was a talker, and even when we were out for dinner would whisper into my ear that when we got back to my hotel room she would torture me to death with tickling, and then under the table I would feel her bare foot snaking its way into my lap to be tickled, and she would arouse me with the look on her face as she tried to order her meal while I tormented her sole with my fingertips. She was a contortionist, and when we made love she would wrap her legs behind her neck and present to my lips and tongue the tender bottoms of her feet to be licked and kissed while we fucked, a combination that I think to this day distended my cock to the longest length and largest girth it has ever known. Although she almost couldn't stand it, she would allow me to tie her up and tickle her armpits and ribs as I mounted her, and her cries of ecstasy were so piercing that often we would collapse in exhausted laughter afterward as the angry thumps from neighboring rooms assaulted our ears. She loved to have her toes sucked and lightly bitten, and she would have me do this while she masturbated herself, and then when she was ready to come she would drag me away from her feet and pull me on top of her, and grind her crotch into mine while ferociously tickling my sides and hissing into my ear a stream of sex-talk that constituted a jumble of the words

fuck, cunt, cock, and tickle. It was hard not to relocate myself in Argentina so that we could indulge in each other for the rest of our lives, but there were personality problems between us, and when I was called back to the States I was almost grateful for the excuse to leave. I still think of her to this day, even though I know she immediately took up with someone else, and is passionately enjoying him, and his fetish (whatever it is), just as she enjoyed me and mine.

But my true stroke of good fortune came when I met Reiko, a Japanese woman born in Tokyo but raised in New York, and employed by the placement firm I worked for. She was short and a little on the stocky side, but her legs were perfect, her face adorable, and her feet, which I noticed right away, were always sandaled and adorned with toe rings and bright nail polish. She seemed shy, so I took my time getting to know her. My cubicle was not far from her desk, and one day I heard a rhythmic smacking sound and peered out to see what was causing it. It was Reiko idly slapping a ruler into the palm of her hand while she mused over some documents before her. As I watched, the slaps became harder, and then she felt the pressure of my stare and looked up to see me smiling at her. Her face flushed and she looked away and placed the ruler quietly on her desk, but I noticed the trace of a smile on her lips. A few days later I asked her out to lunch, and things heated up very quickly after that.

The "caning" of her own hand with a ruler, and more importantly her embarrassed reaction to being caught at this symbolic act, held some promise for me, as I considered an appreciation for the sadomasochistic arts a prerequisite for a tickle mate. Not that I wanted a lady

who was into caning, but I longed for one who would not shrink from bondage as I taught her the ins and outs of erotic tickling. By the sheer force and breadth of her intelligence, Reiko surpassed all of my expectations on our second date. Slyly, I had asked her to my apartment for dinner and then a night out at a jazz club. My hope was that a leisurely meal and a few glasses of wine would put her in the mood to forgo the jazz club and choose instead a night of sensuous play in my tickle lair. She arrived at my apartment in a tight dress that showed her body to be less stocky than I had thought, but packed with muscle around her midsection, a carry-over, I soon learned, from her days as a gymnast. Her long raven hair hung down her back and over her forehead in bangs, her ruby red lips were pursed in a quizzical smile, and as I took her coat I snuck a peek at her sandal-shod feet, and was not disappointed to see her toenails shining with a fresh coat of bright red lacquer, and the middle toe of her right foot sporting an opal toe ring. After the usual small talk and polite interaction, she astonished me by asking point blank if I expected that we would become lovers. Before I could answer, she apologized for her lack of subtlety, and explained that she had not had many lovers, nor did she intend to, but that when she found someone interesting and sexy, she did not believe in playing games. I think I responded by telling her something akin to the fact that her apology was unnecessary, and did she realize how refreshing and dreamlike such a statement was to a man who, regardless of his attractiveness to women, had to play those very games she was now offering to toss aside? Rather than continue in this rather dry, intellectual mode, I thought it wise to soften things a bit by moving in for an embrace, and a gentle kiss, which she accepted with de-

mure charm. Reader, within minutes I was forced to rush into the kitchen and turn off the oven; dinner would not be served anytime soon. In my plush double bed, Reiko and I began our affair of the heart that would last for a decade, ending in a tragedy that I will describe but briefly at the close of this narrative, as my focus here is on the incredible joy and pleasure we shared for so long.

As she stood in my candlelit bedroom, slowly stepping out of her clothes, Reiko told me that she had often caught me looking at her feet. Before I could respond, she laughed and said that I should not be embarrassed. Her feet, she knew, were very beautiful, and so she had always presented them in such a way as to attract a man who would appreciate them. I told her that she was right, that I had certainly admired her lovely feet and would consider it an honor to kiss them, if she would let me. Without another word, she fell upon the bed and opened her arms to me, a lovely, warm smile on her beautiful face. I shed my clothes with astonishing rapidity and knelt between her legs. She brought her feet up to my face and I avidly kissed and licked her delicate toes and the soft, silken soles, noting with delight that they were scented with jasmine. It was obvious that she enjoyed this, for she made no move to take them away, and her heavy breathing soon graded into moans of pleasure. By the time I had removed her opal ring with a light pulling of my teeth, savoring the added smell of her recently applied nail polish, she was pulling at my flanks, drawing me into her. I knew this was happening too fast; I wanted to hold out and give her the full benefit of my ardor, but I could not resist the mysterious electricity that sparked between us, and I found myself slowly entering her while she gasped with joy and squeezed her legs around my waist. I held myself back, then, and

brought my lips to hers, and kissed her deeply while my cock moved in and out of her with a tantalizing slowness. For a long time we kissed and stroked each other, and I was pushed beyond the limits of my control by the teasing character of her caresses. It was apparent to me that her natural instinct was not to knead and press her hands upon her lover's flesh, but to lightly touch and tickle. (Later on we discussed this philosophical aspect of the libido, and agreed that people tended to fall into an either-or category as ticklers, or squeezers; cheerfully, we concurred that we both fell into the former category.) Regardless of my intentions, I could not prolong my orgasm, and after a shockingly short duration of lovemaking I stiffened and shuddered in the throes of release, gratified, at least, by the knowledge that my spasms had set her off, and that she was also surging through her climax. Despite the initial overtones of foot fetishism, it was a very standard, albeit beautiful episode of lovemaking. We lay next to each other, sweat-soaked and contentedly smiling, and embarked on the mental and emotional communion that would keep us physically fused as well for a long time to come.

She was a charming, innocent woman, pure in her heart and soul and sexual impulses. Her libido was very strong, but sex without a deep emotional connection left her feeling empty, so she had not slept around much. She could not fully explain why she chose to open up to me so quickly, other than to say she had an intuition that we would fall in love. Highly intelligent, she had read extensively in the literature of sex, and had concluded that she was supremely healthy in her attitudes and responses, despite the fact that she was "obsessed with tickling." The reader can only imagine how I reacted when I heard that phrase, "obsessed with tickling," uttered from the lips of

this nubile, Asian goddess who lay asweat in my bed, her painted toes and painted lips slick and glistening, her big brain humming with the erotic possibilities privy to the creative sexual explorer. I wanted to know everything, I said. Every nuance, every dream, every experience that had led her to this conclusion. In the course of a thrilling year of dissolute nights and languid, lascivious days, she told me the story of her life as a tickle freak.

Oddly, she had no recollection of any incident in her childhood that had caused her to fixate on tickling sensations. An only child, there were no sadistic older siblings to pin her down and tickle her ribs until she wet herself. Nor had an uncle, grandfather, or beer-breathed neighbor attacked her with clumsy fingers and thumbs. All she knew was that the very thought of being tickled, or of tickling others, had always caused her genital juices to flow. Her conservative Japanese parents had been overprotective, and she had remained a virgin until her freshman year in college, when she yielded to an older man, an African American professor of history, who was sexually ardent but not interested in tickling. After the affair ran its course she fell in love with a fellow student of Japanese descent and they were together for two years, during which time her tickling fantasies dovetailed adequately with her boyfriend's interest in elaborate rope bondage. When she discovered that he was bedding other women on the side, she terminated the relationship. Distraught, she remained alone for another year, satisfying herself by masturbating while tickling her ribs, belly and nipples with feathers and soft brushes. A couple of drab one-night stands made her more determined than ever to wait for Mr. Right, and then she met me.

I wish to emphasize that our romance grew into something deep and meaningful as the result of our shared interests and attitudes, and not solely on the basis of our mutual ticklemania. It was the only time in my life when I felt an ineffable soul-to-soul connection (the reader will kindly refrain from punning that I also felt a "sole-to sole" connection). In short, it was true love, and our sexual chemistry made it magical indeed.

We were of the same mind regarding bondage — that it is a superior method of enhancing the tickle experience — and so incorporated spread-eagled helplessness into our lovemaking right away. We never tired of tying each other up, but in the interest of mental health (or the appearance of it, at least), we tried to enjoy tickling without bondage, and became quite successful at it. As a discipline, we sometimes fucked without employing the butterfly caresses and tickles that we craved. Often our mutual desire drove us to a quickie in a standing position, in a hallway or alley somewhere. These were the kinds of sexual connections I had always disdained as boring, but with Reiko they seemed natural and exciting. Most of the time, though, it was tickling that propelled us into the sexual stratosphere. Whoever was on top could be assured of being ruthlessly tickled in the armpits and on the sides during our slow copulation. Reiko proved to be an expert fellatrice, and her tongue tickled my cock to many an orgasm while her fingertips danced lightly across my pulsating scrotum. Tickling became so ingrained into our relationship that sometimes we carelessly tickled each other in the presence of others, and our lewd reactions threatened to give the game away. Not that we were ashamed of our orientation; we simply were not interested in sharing our sex lives with others. After a two-year court-

ship we married, and for both of us it was eight years of bliss before we decided to start a family, and when Reiko became pregnant it may have been the happiest three months of my life.

I choose not to address the matter of her unexpected death during her pregnancy. The accident that took her and our unborn child from me could not have been prevented, and I prefer that the reader remember Reiko as the laughing, sensuous, life-affirming woman who made my dreams come true for a time longer than that which most lonely souls are given on this planet.

After a long period of grief, and an even longer one of almost catatonic depression, I found the strength to get on with the business of life. My sexual liaisons then were few and generally uninteresting, more occasions for satisfying a basic need than romantic encounters promising longevity. Tickling entered into them in ways I barely remember. I do recall one buxom woman of advanced years who was fascinated to learn of my fetish, and took pleasure in tickling my ribs and belly with her tongue while she sat on my face and enjoyed cunnilingus, but that was a phase of my life when I drank rather heavily, and so the details are lost in an alcoholic fog.

These days are better. The memory of Reiko will always haunt me, but time encrusts even the most sensitive natures, and I have moved on. Currently I am involved in a monogamous relationship with a thirty-five-year-old divorced woman. She enjoys every aspect of the tickling arts, and our couplings are energetic and satisfying. Her small (size five), exquisitely formed feet are highly ticklish, and the merest touch of a fingertip to her delicate sole or instep will cause her to shriek and thrash wildly. At

first I thought this would be a problem, but in fact it is part of her fantasy. She finds tickling unendurable, and wants to be restrained and gagged and tormented almost out of her mind, at which point veritable geysers of that elusive nectar, female ejaculate, signal her readiness to be royally fucked. Needless to say, I am always willing to oblige her. She is a giving person, and loves to tickle me because she knows it gives me pleasure. But we have little else in common, so I expect that we will eventually part. Nevertheless, I am content to enjoy her for the time being, and to fantasize about what may lie ahead."

And that is the case history of "Michael," whom the astute reader has certainly concluded is none other than the author of this book. All of the details of the case history are true, including the suggestion that I have found happiness again, for who could be happier than a tickle fetishist engaged in the writing of a book that will make him the Johnny Appleseed of Erotic Tickling?

8 A Potpourri of Tickling

L
et us now examine ET in general, as it is manifested in our society and in the media, and as it has been viewed throughout history.

Historically there is not much on ET. Occasionally an episode of tickling turns up in the tedious copulatory narratives of the Victorian era, but on the whole the pornography that predates the twentieth century is devoid of ET. I have a theory about this.

As I have already suggested, there is a strong link between foot-fetishism and ET, for the obvious reason that feet are usually perceived as the most ticklish part of the body. (In fact, ribs, armpits, and other parts are often more ticklish, but feet have been assigned "most ticklish" status because, other than in the culture of ancient China, they had little importance besides support and locomotion.) However, foot fetishism is a relatively recent phenomenon, since throughout human history feet were unhygienic and grossly calloused, and consequently lacked erotic appeal.

A diligent scholar (whose assistance I would welcome) may unearth tidbits of tickle lore telling of Roman courtesans who were prized for their pretty feet, or tales of Cleopatra, who was rumored to have used her feet and toes in remarkable ways. But in the main, the ages before the advent of plush carpeting, indoor plumbing, and the trillion dollar shoe industry produced feet that were hard as animal hides and blackened with ground-in dirt. Foot-fetishism, then, and by extension tickle-fetishism, are refinements of high civilization. Shoeless aboriginal women with soles thick as the paw pads of dingoes are not likely to inspire foot-tickling porn; that honor is reserved for pampered ladies in European salons enjoying their weekly pedicures.

A notable exception appears to have been the royal court of Catherine the Great. In 1786, Sir Robert Ownsley, Special Emissary to the Russian court, observed peculiar goings-on, which will be of interest to the reader of this book. According to information posted on the Internet, Sir Robert was privileged to observe the Czarina's Professional Foot-Ticklers (as he calls them) in action. A young girl who had committed some transgression or other was bound, unshod but otherwise fully dressed, to a curved couch. The Ticklers, two attractive young ladies, began their work with soft brushes and fingertips. Sir Robert describes the victim's reaction thusly: "She struggled with such vigor as to shake the couch that held her securely. After several minutes her laughter and screaming seemed to be that of one demon possessed."

Further on, he notes the skill of the ticklers: "The woman with the brush seemed to know each and every possible nuance of the sole of her victim's foot. Her stroking was very deliberate and planned, taking care to the brushing of the sides and tips of each toe, following the lines of the arch with artistic accuracy, even though the foot was squirming and jerking about in desperation. She seemed able to anticipate the movement of each jerk. The girl who was using her fingers seemed equally adept in

stroking, nay caressing the sole in wave after wave of maddening ten-finger coordination."

Hmmm. I wonder if it's likely that an eighteenth-century diplomat would have used the term "professional foot-tickler." The phrase sounds like something dreamed up by a present day podophiliac, and so casts doubt on the legitimacy of the account. Regardless, it is a documented fact that Catherine did employ maidens to tickle her feet as a way of heightening her arousal prior to coitus. How unfortunate that such tickling by itself could not satisfy the lustful Czarina, who allegedly died when a horse fell from its suspended height and crushed her as she awaited the penetration of its gigantic phallus.

The gradual emergence of ET as a sexual kink is the result not only of a civilization that is better able to pamper feet, but also of the fact that humanity is now blessed with more lei-

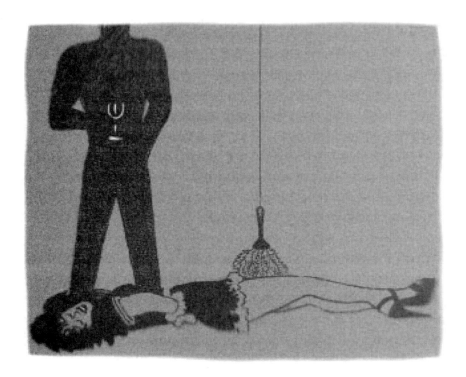

sure time and freedom from the struggle to survive than ever before. It is still a cruel world. Poverty, natural disasters, war, disease, etc. remain very much with us. But even the gloomiest observers of society will be forced to admit that this is a unique period in history when a great many people have the time and the money to indulge in sexual explorations that a sharecropper or serf could not have considered. A man doing back-breaking labor all day long might occasionally find the energy for rutting, but he will not spend his few spare moments thinking up tickle games.

It's difficult to ascertain whether the underground community of tickle freaks has grown over the years, or whether the Internet has simply made them more visible. In all likelihood, both claims are correct. Regardless, the Web now provides connoisseurs with a wealth of tickling material. While writing this book, I spent many hours using search engines to locate ET sites. By typing in such words and phrases as "tickling," "foot-tickling," and "erotic tickling," I managed to wade through the chaff and hone in on the very best places to see tickling erotica. Here is a brief account of my Internet tickling adventures.

The first impediment to my quest were the many listings of sites where tickling was mentioned in passing, as in "tickling the ivories," or "rib-tickling joke of the day." These were eliminated by focusing on erotic tickling, but led to the next hindrance, aggressive hard-core sites that lured me with tickling come-ons and then clogged my computer with adhesive images of anal rape, torture, pre-pubescent sluts, zoophilia and other horrors. It was like wading through a leech-infested bog to get to the pellucid stream shimmering in the distance, where nymphs and sprites frolicked in a languorous orgy of laughter and tickling. Well, I didn't exactly find *that* kind of site, but there were some pleasing results.

Many tickling sites have been constructed by amateurs who long to share their interest with like-minded souls. These are user-friendly and have numerous free pictures, usually arranged in galleries of thumbnail photos that can be enlarged by a click of the mouse. The photos range from amateur snapshots of bound feet being tickled by a disembodied hand to the more profession-ally presented shots of an attractive, nude model in serious bondage being tickled by an equally attractive, nude model. These latter photos are stills from various tickling videos offered for sale by companies such as Realtickling.com. (Some of the titles of these videos are cleverly conceived: *Dr. Tickle and Mr. Tied, Julius Teaser,* and *Count Tickula* are three that come immediately to mind.) One of the first things I noticed during my explorations was that the professional pornographers tend to show women tickling women; one supposes their marketing research indicates that the major-ity of those wiling to part with $39.95 for a video called *Tanya's Tickle Torment* are heterosexual men who don't want their mastur-batory idylls punctured by the sight of another man's hairy forearm and sausage-like fingers. Alas, most of the tickling images found on the web are rather sterile. The scene is often a couch in a living room, or a bed in an obvious motel room. Sometimes the shot occurs in a makeshift dungeon, with bare walls surrounding stocks or a bondage table. Women are tied with their hands over their heads so that their armpits are exposed to tickling finger-tips and feathers. They are hogtied and their naked or stockinged feet are put to the tickle torment. Variations abound. Tooth-brushes, peacock feathers, feather dusters, even the quill ends of goose feathers are scraped across bare soles and arches. Feet, arm-pits, sides and tummies are the most frequent targets. Ticklers include beefy, bare-chested brutes in executioner masks, nerdy, fully-dressed tickle-fetish types, and women — young, old, fat, skinny, nude, semi-nude, barefoot, spike-heeled. Some are tick-

led in nylon hose. Elmer Batters, a famous Los Angeles photographer of women's feet, created his own look: grinning girls showing their feet to the camera — bottoms up — wearing black-seamed nylons and spreading their toes wide apart to resemble the slats of a picket fence. Tickled feet in this pose can be found all over the Web.

Not only photographs, but artwork as well turns up on tickle sites. Here fantasies run wild, and badly drawn, impossibly big-titted bombshells are shown tied to a bed while ingenious tickle-torture machines operate in close proximity to their naked, straining feet. A multi-tentacled creature from another world tickles a shrieking captive on more parts of her body than a mere two-handed earthling would have access to. Pirates, banditos, Bedouin warriors all get in on the act. Even animals — anything with a fluffy or pointed tail — are put to work. While most of the art is poorly executed, there are a few real artists who seem to have an interest in tickling. Saudelli, an Italian cartoonist, has produced panels of beautiful women subjected to tickle torments, and these will delight most tickle freaks.

Printed matter is even more accessible. A common type is the "tickle story," a vivid account (often first-person, and usually, one assumes, entirely made-up) of extraordinary tickling events. A haughty coed is humbled by a gang of her sorority sisters who strip her naked, tie her to a bed, and tickle her for hours. Such stories, if competently written, can be quite erotic. The "sorority tickle-torture" type of story (and its variants, involving any situation where one victim can be overpowered and tickled by a multitude of angry females — such as a summer camp, cosmetology school, etc.) excites the reader with its description of a helpless victim, who must endure the ministrations of not one, but as many as a dozen avid tickle-fiends. In this scenario, every sensitive place on the body is diabolically tickled *at the same time*, and of course

also while the genital area is pleasured. Such, as was said of the Maltese Falcon, is "the stuff that dreams are made of."

Amid the highly erotic, fabricated tales of gang-tickling, and the straightforward accounts of boy-girl tickle sessions, one will encounter stories that appear to have been written by lunatics. Perhaps that's a bit harsh. Let's just say that some of the stories are silly in the extreme. Usually these involve the activities of master spies, super heroes, space aliens, or celebrities, and all of them entangled in a mysterious web of tickling. A sure sign that you are in the clutches of a tickle nutjob is the presence of long, *really* long stretches of onomatopoeic dialogue that goes something like this: "NooooHAHAHAHAHAHA! Make it stopHAHAHAHAHA! Nnnnngh! No, God no! Please not my feet, Nooooo! Aaaggh, hahahaha, mngh, please!" And that — trust me — is a rather restrained and concise example. These outbursts are usually found in stories like "Tickled Angels," in which the stars of the famous TV show must solve the murder of a woman who has been tickled to death, discovered with "a pink feather laid across her toes." The plan calls for the Angels to "infiltrate the Boston tickling underground," and since the spy will have to endure tickling tortures while on assignment, all the Angels must be tested to see who has the least ticklish feet, sides, and armpits. And this is just the opening scene!

On the web you will encounter a cat burglar and the nude, ultra-ticklish girl he (or she) tortures for the combination to the safe. Go to another site and you will find the saga of a picked-on member of a high school girl's track team whose teammates relentlessly tickle her tender feet (after practice, they're softened from sweat socks and tight sneakers!) until the lesbian coach appears in the locker room and — surprise! — exhorts the lassies to more ingenious tickling schemes. My personal favorite is a bizarre story in which talk show shrink Dr. Laura is subdued by an angry

studio engineer, forced to inhale laughing gas, and mercilessly tickled with a Q-tip.

When at last you have tired of self-titillation and seek informative articles on tickling in general, the web will provide these as well. In the course of one evening's perusal of tickling data I learned the following:

— A neurophysiologist in Stockholm used magnetic resonance imaging "to compare the pattern of brain activity from anticipation of a tickle with that of an actual tickle on the foot." The research proved that "as far as the brain is concerned, the threat of a tickle is the same as the feel of a real tickle." Silly brain.

— Scientists at London's University College constructed a robotic tickle machine and unleashed it on ticklish volunteers. Then they had the same volunteers tickle themselves; according to the volunteers, the robot did a better job of it. Results showed that the self-tickling produced heightened activity in the cerebellum, suggesting that this part of the brain "acts as a killjoy, squelching the tickling response if the tickling doesn't come from an outside source. (It was not stated whether any of the volunteers offered to purchase the tickle robot at the close of the experiment.)

— Researchers at Scotland's Stirling University declared that their own experiment, using another tickle robot, "made a crucial advance by determining the most ticklish spot on the body." Apparently, it is a small area on the sole of the right foot. Not the left one, mind you.

— A professor of Psychology at Bowling Green State University is conducting research in the chemistry of laughter,

in order to better understand how to treat depression and sadness, and he believes that tickling may play a useful role in the future. Devotees of ET can save this man a lot of time and trouble. After all, who can possibly be depressed when being tickled to orgasm?

Finally, from a Q&A column by Betty Dodson, noted sex therapist, here is an excerpt on tickling so insightful that it deserves to be quoted in full:

Tickling or being tickled is rarely discussed in relationship to sexual pleasure. Some people see it only as a child's game, but as adults, we continue this activity throughout our lifetimes. After all, most of us learned about tickling from our parents who koochie cooed us as babies in our cribs. My mom did "This little piggy went to market" on my toes, which I remember fondly to this day. We can learn a lot about someone by how they respond to being tickled. Children who have been abused by clumsy parents tickling them excessively can end up with strict boundaries about being touched and never develop a sense of playfulness that is an important part of good partnersex. Those who cannot stand being tickled at all might be suffering from pleasure anxiety.

Wilhelm Reich was the first sexologist to coin the term "pleasure anxiety," and it's very much a part of our culture. Our basic mistrust of enjoying physical aspects of our bodies comes primarily from religious doctrines. We are afraid of having "too much" of a good thing especially when it comes to sex. For many years I've watched my clients fight off impending orgasms by bucking, screaming, and twisting as if they were wrestling with the devil struggling to avoid the intense sensations of sexual climax — the very thing they long for. Perhaps being tickled could become a form of therapy for them.

My own personal take on tickling someone is to discover how much sensation they can tolerate, and to discover if I'm playing with someone who has a good sense of humor and fair play. After all, tickling leads to laughter that relieves tensions and releases endorphins. Both contribute to human happiness and we could all use more of that. Now when I'm being tickled past my level of tolerance, I see it as an opportunity to push my boundaries and practice letting go. As a control freak, it's fun for me to experience this playful form of surrendering. One of my first bondage fantasies was to be tied up and tickled until I melted into a heap of laughter and tears.

Hey Betty… call me.

EXTREME TICKLING

As I previously mentioned, in tickling the line between ecstasy and violent discomfort can sometimes blur. Skillful couples who know exactly what they like can usually avoid this shadow zone, but the less experienced may find a lovely session tainted by the submissive's irritation or panic at being tickled too harshly or too long. Others, however, go boldly into that region where the tickling becomes an SM experience to rival flagellation or clamping.

As it happens, I am a person who has no desire whatsoever to experience any kind of discomfort. Consequently, while being interested in SM on an intellectual plane, I have never been able to appreciate it in a sexual way. Like many people, I shudder at the thought of being subjected to the sting of the lash or the biting teeth of the alligator clip. Yet I am fully aware that others, for whom the aforesaid "punishments" would be considered divine, cannot endure even a few seconds of tickling.

The mystery of why one person's pain is another person's pleasure may never be completely understood, but Jay Wiseman, in his excellent book *SM 101,* points out

that masochists "seem to have a different type of nervous system than the rest of us have."

"Many masochists," he continues, "report entering an altered state of consciousness. If they feel safe and secure about their situation and the people they're with, they relax and surrender to an astonishing degree. They sometimes enter a mental state where the blows no longer feel unpleasant. One reported that the blows from a heavy wooden paddle felt like gentle drops of welcome, warm rain falling on a faraway part of his body. Masochists seem to have states of consciousness in common with yogis, fakirs, and other people who follow altered-consciousness pathways."

It is clear, then, that the kind of tickling I have promoted in this book may not be for everyone. The masochist who seeks a tickle-experience akin to the acute sensations induced during serious SM will not be satisfied by feathers and lightly dancing fingertips, although this might be a useful way to begin the extreme tickling session. Gradually the tickler escalates to a stiff brush on the soles of the feet and hard kneading or poking of the ribs, knees, armpits, and groin. Depending on the ticklee's level of masochism, this can go on much longer than usually prescribed, and as long as a safeword is in place, will continue regardless of cries for mercy.

At this point the tickler will be challenged to be at her most artistic. Sensing the submissive's limits and desires (and armed with knowledge gleaned from a preliminary discussion of what to do and how far to go) she will slow down, speed up, or tickle with maddening consistency. The genitals may be completely ignored, or teased to induce a pre-orgasmic ache that will not be relieved. What happens next should be agreed upon in advance.

One submissive will want to be brought to orgasm and then further tickled. Another will want his orgasm denied, perhaps even preferring the session to end without relief. He can use his pent up sex energy to propel him through entire days of servi-

tude to his tickle mistress, who might at any moment command him to assume a position of vulnerability and commence ardent tickling. Just as a sexual slave will often clean floors, buy groceries, and do other mundane chores for his mistress, so too will a tickle slave be alert to his tickler's every whim.

The submissive may be ordered to lie or stand completely still, without the assistance of bondage, while the dominant goes to work tickling his most sensitive places. Any movement at all will be cause for dire correction. Tickling can be combined with spanking, pinching, verbal humiliation, or any other SM practice. As with more gentle tickling scenarios, the elements of an extreme tickling session depend solely upon the desires of the

participants. Other than honoring safewords and doing no harm, there are no rules.

One last word about extreme tickling: the tickling itself does not have to consist of harsh poking and prodding. A light touch may prove equally excruciating if the ticklee is highly sensitive. Duration, insistence, and lack of mercy will be the keys. A submissive who knows that mercy is not forthcoming will experience tickling *in extremis*. Consider the following account by Janice, an elementary school teacher in New England who found a way to combine her desire to be humiliated with a love of tickling.

"My husband and I have always enjoyed soft caresses and light tickling during foreplay and intercourse. In time we started playing around with bondage and found that we both liked taking turns being tickled while we were helpless. Sometimes when I was tied the tickling would make me feel like peeing, so Jon would untie me and I'd run to the bathroom and do my business. But every time I got to that point I would become *very* excited, and would find myself almost wishing he wouldn't untie me, that he'd just keep on tickling me until I wet the bed. This freaked me out a little, but eventually I got up enough nerve to tell Jon about it, and to my surprise he said it sounded really sexy. So one night we put a rubber sheet on the bed and I stretched my limbs out for bondage and thought to myself, well, here we go.

"I was so nervous that I was trembling all over, and Jon did little to put me at ease. In fact, he was even a little mean, but of course that was all part of the scenario. He started by tickling my feet with soft brushes and telling me that I'd been a very naughty girl and had better not cry out or move around while taking my punishment. He also said he was aware that my bladder was full (which was true — he'd commanded me to drink two large glasses of water prior to our session), and warned me that I'd better not wet the bed or there would be terrible consequences. My feet were very sensitive that night, and as he worked on my soles and

insteps I felt the first ache of having to pee. Gradually he moved up my legs to my knees and thighs, and when he got to my belly I was groaning and begging him to untie me so I could pee. I should mention that on this occasion we had agreed that I would be tickled until I lost control and wet myself. Knowing this put me in a state that I had never experienced before. I felt more helpless than I ever had in my life, and utterly without hope that my fate could be averted. When he put aside the brushes and started moving his fingertips lightly up and down my sides and across my ribs and into my armpits, and then back down again, over and over, I began to thrash and cry out for him to stop. I begged him, said I didn't want to do this. But no matter how much I pleaded, he wouldn't stop. While he tickled me he licked my nipples, which were by this time as hard as little diamonds. I couldn't stand it, but I guess for me the idea of wetting the bed was really taboo, because I kept holding out, even as I was beside myself with agony and dripping with sweat.

"Finally I just couldn't take it. 'Oh no,' I cried, 'Oh no, I have to pee! I can't hold it anymore!'

"At this point he began to berate me, saying that I was a dirty girl and had better not empty my bladder before he was through tickling me. And of course he was merciless with his fingertips, moving them down now into the region of my lower tummy and groin, to agitate my bladder even more. That was it. I gave out a deep groan and let loose, pouring my pee out all over the sheet, and at that very moment, when I was practically crazy with sensations and emotions I had never felt before, he placed one of his fingers on my clit and rubbed steadily, and I found myself bucking into the most intense orgasm of my life, while he hissed in my ear, *'You're a dirty girl, a dirty, filthy girl!'*"

Janice has not told her husband that her orgasm was the most powerful of her life, and has repeated this experience rarely, as it is a little *too* extreme for her. But after having been opened

up in this way, she has become more sensual and orgasmic than ever, and feels that the power generated by this extreme tickling session has lodged in her sexual memory, waiting to be unleashed.

An obvious caveat that accompanies extreme tickling is concern for the health of the submissive. Intense tickling decreases the "tidal volume" of the lungs — the amount of air they are able to take in and hold — and is, for that reason, a form of breath control play. (For a far more detailed and learned discussion of the risks of breath control than I can include here, read Jay Wiseman's essay on the subject at *http://members.aol.com/Oldrope/breath.htm*). The risks of extreme tickling are increased if you combine it with other activities that affect breathing, such as corsetry, positions that make it harder to breathe such as face-down or bent-over positions, or gags. Don't subject someone to wild tickling if they have a weak or damaged heart, or asthma or any other breathing problem that could be exacerbated by hyperventilation; it's just too risky.

Like any other form of risky BDSM play, you have to make your own informed decisions about whether or not to engage in intense tickling. Do your homework, talk to your partner and your doctor, and think with your brain, not your genitals.

10 FINDING A PARTNER

L
et us not pretend: there is no magic formula for finding a tickle partner. Furthermore, anyone who prefers or requires a particular kink during sex is at a disadvantage.

That's the bad news. But there is good news as well.

If you've read this far, you should be convinced that Erotic Tickling is a harmless and pleasurable activity that many people naturally enjoy, and that others can learn to enjoy once they get past their initial ignorance or hesitancy. So you have a decent chance of hooking up with a partner who likes tickling as long as you conduct your search in a commonsensical manner. I believe there are two basic ways of looking at this search.

First, the perspective of one who seeks a sexual partner, with or without the possibility of a long-term commitment. If you're just trolling for an ET buddy, you can proceed in a very straightforward fashion, attending fetish clubs, going to singles bars, and advertising in specialized magazines. You may even want to start a singles' tickling club, if you live in an area with a population base that will support such an endeavor. Since you are prima-

rily interested in a good time, you can be direct, eschewing court-ship rituals and cutting right to the chase: "Hey, good-lookin', like to have your armpits tickled?" Of course, this is still a matter of style and circumstance. Even in a fetish club, a woman might expect *some* measure of courtliness before the come-on. But the point is that since your goal is specific and clear, your methods can lack subtlety and still work. In the gay milieu especially, game-playing (not to be confused with role-playing, a great delight) is dispensed with so that the sexual connection can be effortlessly made. I am unaware of any existing sartorial signals (such as the placement of bandanas, key chains, etc.) for devotees of ET, but herewith suggest the wearing of feather-pendants. A pink or white feather could indicate submission, and a dark blue or black feather dominance.

Next, the perspective of one who seeks a mate, a lover, a life partner who appreciates the sensual splendors of ET. This is a trickier business. In my opinion, it is necessary to put one's ET orientation on the back burner. In particular, if you are a hetero-sexual male, understand that most women will want a mate who is relatively normal, who can pleasure them in the conventional way of sexual intercourse, and who is a well-rounded manly man not prone to weird little obsessions involving canary feathers and bare feet. I apologize to feminists, whose societal gains have been sig-nificant and necessary, but personal observation tells me that the majority of men and women will always be slaves to traditional roles, and prefer their mates to embody feminine or masculine ideals. In other words, guys, attract your special woman by being an accomplished person first, and a tickle-freak second. Once you are loved for who you are, your fetish will be tolerated, or better still, embraced.

This is true for both sexes, and that's why I said there is no magic formula for attracting a tickle partner. It's simply a matter

of being yourself and then playing the numbers game. Self-improvement is the first step. Make sure your communication skills are honed, and that you are as attractive and well-groomed as you can be. A confident (but not arrogant) manner is attractive to both sexes. And of course none of your attributes will do you any good unless you get out of the house! A friend of mine who is by no means a matinee-idol in the looks department, nevertheless seldom lacks for female companionship because he has always put himself in what he calls "the path of probability." He gently hits on women at museums, supermarkets, or jogging paths, and even though he is usually rejected, success comes eventually, and then so does he.

Should you lose heart, think of the world's ongoing population explosion. Bad for humankind in general, but good for those with a kink, for the odds of finding a compatible partner get better every day.

If You Are Alone

If you are alone, if you have no one to share your love — and your love of tickling — do not despair. There is someone out there for you, and in the meantime you are free to engage in the universal and thoroughly acceptable practice of masturbation.

It is a popularly held belief that you cannot tickle yourself, and probably this is true if by tickling you mean the ardent poking and prodding of your own ribs until you cry out to yourself for mercy. But by having read this book, you know that ET is something you can very easily enjoy by yourself when the fancy strikes you. Tickling yourself, with your own fingers, or, better yet, with a feather or brush, will produce excellent results, especially in congress with visual aids (ET photographs and drawings from tickle sites on the Internet). Let your imagination go where it will, and have a wonderful orgasm without the slightest tinge of

shame or sorrow. As you are gentle, loving, and sexually provocative with yourself, so you will be with your mate, when he or she at last appears.

By practicing on yourself, by loving yourself, you create an inner peace that shines through, and will be attractive to others. The loneliness and frustration you may feel now will eventually be transformed into joy when you are in the position to share with another person what you have learned in your solitary explorations. If the focus of your desire is as much in giving pleasure as receiving it, you will find happiness.

ABOUT THE AUTHOR & ILLUSTRATOR

Michael Moran is the pseudonym of a well-known author of articles and nonfiction. Based in the Northeast, he has been joyously tickling and getting tickled for his entire adult life, and is currently (and happily) in a long-term relationship with an extremely ticklish woman.

Chris M is an artist and writer, living in Washington DC. His artwork illustrated Joseph Bean's *Flogging* for Greenery Press, is collected by the Leather Archives and Museum of Chicago, and hangs in the DC Crucible, the Baltimore Playhouse, and private playrooms from New York to New Orleans to Maryland Dungeon Country. His email is *chris_m39@yahoo.com*.

Other Books from Greenery Press

*Please include $3 for first book and $1 for each additional book with your order to cover
shipping and handling costs, plus $10 for overseas orders. VISA/MC accepted. Order from:*

greenery press
3403 Piedmont Ave. #301, Oakland, CA 94611 toll-free 888/944-4434 www.greenerypress.com